S0-ABR-645

The Cong

raining school

d, a sanatorium,

S: Candidates

than 30

d moral char

n every leg

ht intention

ution.

is of

Contents

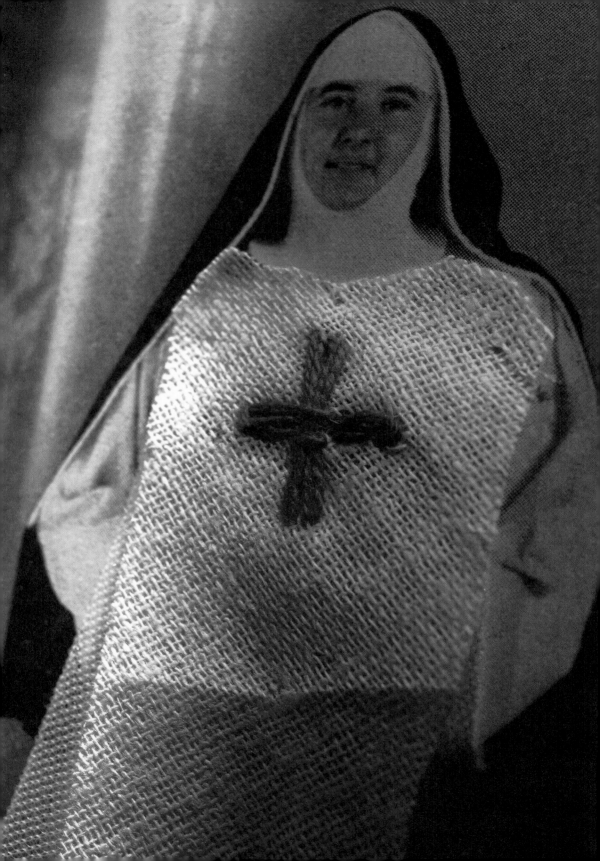

Foreword

Suzanne Bocanegra explores the various dangers women face in society through her innovative reinterpretations of a ballet, an opera, and a film, presenting them as gallery installations in the exhibition *Poorly Watched Girls*. The subject is timely but not new, and her sources for the three new works she presents at The Fabric Workshop and Museum span more than two centuries. Perpetually working in both the realms of art and theater, Bocanegra is interested in how women in trouble are dramatized in popular entertainment. Her background as an artist and theatrical designer—mostly for experimental theater—led her to incorporate costumes and stage sets in these works of art that also integrate elements of her earlier work. Her interest in folkloric artifice and historical painting as well as collage and textile are the aesthetic underpinnings of the pieces shown in this exhibition.

La Fille mal gardée, one of the earliest ballets in the modern repertory, was first performed in France in 1789 and since then has been reimagined many times and set to at least a half-dozen different musical scores. Frederick Ashton's 1960 interpretation of it for the Royal Ballet in London inspired both the title of Bocanegra's show, which is loosely translated from the French, and one of the works in it, *La Fille*. A spot-lit plaster bust of a young girl cast from a nineteenth-century sculpture represents *La Fille*, who in the ballet was poorly watched by her mother and as a result ran off with her lover rather than marry the rich old man chosen for her. It peers out across a darkened gallery, flanked by theater flats and dramatically altered mannequins that serve as armatures for Bocanegra's richly layered assemblages.

Francis Poulenc's 1957 opera *Les Dialogues des Carmélites* tells the story of spiritual crisis during the bloodiest days of the French Revolution, as all the nuns in a Carmelite convent north of Paris are marched off to the guillotine for refusing to deny their faith. Perhaps they were poorly watched by God. For her *Dialogue of the Carmelites*, Bocanegra sourced the 1953 edition of *Guide to the Catholic Sisterhoods in the United States*. The book is an index of various monastic orders, each illustrated with a photograph of a nun in her habit. Bocanegra "costumed" the habits by embellishing them with fabric or embroidery, and 162 of these enhanced pages are displayed on a shelf that circles the gallery. David Lang composed music for the installation, sung by Caroline Shaw, that transforms the gallery into a meditative space.

Bocanegra's most poignant inspiration was the 1967 cult film *Valley of the Dolls*. Judy Garland was hired to play a leading part, and her unscripted wardrobe test is the underpinning for *Valley*. Floor-to-ceiling projections of eight highly accomplished women artists face one another, four on each long gallery wall. Each artist duplicates Garland's every move, quip, and glance in the screen test as she

interacted with the film crew, hoping to affect effortless control. At the time that the original clip was made, however, the actress was unraveling, and her vulnerability is interpreted distinctly by each of the eight Judys.

Bocanegra's project embodies all that FWM offers artists: the opportunity to experiment with new ideas and to merge disparate aspects of a practice into a cohesive whole. The generosity of foundations and individuals made *Poorly Watched Girls* a reality. I would like to thank the Coby Foundation, Ltd.; The Andy Warhol Foundation for the Visual Arts; the Joy of Giving Something, Inc.; and the National Endowment for the Arts for their lead grants. I also express my gratitude to Maja Paumgarten and John Parker, and Katie Adams Schaeffer and Tony Schaeffer for their generosity. Henry S. McNeil graciously provided support for this publication.

The FWM studio staff worked diligently with the artist during her residency to re-create Garland's costumes and to facilitate the filming of *Valley*. Under Bocanegra's direction, the staff also spent many weeks embroidering the book pages for *Dialogue of the Carmelites*. Those who played a critical role in the projects are listed in the acknowledgments at the end of this catalogue. I extend my profuse thanks to all of them, especially to Nami Yamamoto, Director of Studio Operations, who oversaw every aspect of production.

We deeply appreciate the generosity of the actors who played Judy Garland in *Valley*. The poet Anne Carson, the choreographer and dancer Deborah Hay, the artist Joan Jonas, the singer and actor Alicia Hall Moran, the actor and activist Tanya Selvaratnam, the actor Kate Valk, the artist Carrie Mae Weems, and the ballerina Wendy Whelan created unique portrayals of Garland. I thank Hal Foster for his insightful interview with Bocanegra and all those responsible for the production of this catalogue, who are listed in the back. Lili Taylor's inspired depiction of the artist in a special presentation of *Farmhouse/Whorehouse* gave audiences an opportunity to experience the touching humor of Bocanegra's performative works.

During the show's installation, Bocanegra arrived at the gallery with black garbage bags filled with old ballet costumes, fabric scraps, trimmings, and assorted objects both new and old that she dumped on the gallery floor. From this seemingly sundry pile she created *La Fille*, a piece of carefully conceived artistry. Bocanegra's ability to conceptualize on a perceptual level is innate to her process, and the result is a body of deeply empathetic work. As a long-time admirer of Bocanegra, I am grateful to her for bringing this landmark project to Philadelphia.

—Susan Lubowsky Talbott, *Executive Director, The Fabric Workshop and Museum*

TITLE VALLEY OF THE

DIRECTOR SUZANNE Bo

ACTRESS DEBORAH H

PART JUDY GA

Suzanne Bocanegra and Hal Foster in Conversation

HAL FOSTER: Let's begin with the title of the show. Why *Poorly Watched Girls*?

SUZANNE BOCANEGRA: It comes from the translation of the title of the eighteenth-century ballet *La Fille mal gardée*, which in English is sometimes called "The Wayward Daughter," but a more literal translation is "The Poorly Watched Girl." I've been working in theater for the past ten years. In the traditional performance world, plays, operas, and ballets are continually restaged. Old works are reinterpreted and made into something new. I wanted to use that approach with this show at The Fabric Workshop and Museum. So I restaged a ballet on the eighth floor [*La Fille*, 2018; pp. 46–73], I restaged a film on the second floor [*Valley*, 2018; pp. 22–45], and I restaged an opera on the first floor [*Dialogue of the Carmelites*, 2018; pp. 74–85].

I used part of the original French ballet title for the work on the eighth floor, but I realized the translated title ended up fitting everything in the show. I originally picked the source material I used for this exhibition intuitively, but later I realized that all three works deal with the ways women and girls are depicted in popular entertainments, and in each piece there is a poorly watched girl or, in *Dialogue of the Carmelites*, girls.

HF: You said, "All these pieces are about women who have no power. Who need to be guarded. Who need to be watched. It's like Superman guarding Lois Lane. We never get tired of it." But it's a good thing that the peasant girl in the ballet is poorly watched because it allows her to escape a situation that would have made her unhappy.

SB: Right. Sometimes being poorly watched is a good thing. The girl in *La Fille mal gardée* is able to escape an arranged marriage because she is poorly watched. My video work, *Valley*, which is on the second floor here, is a restaging of the 1967 film *Valley of the Dolls*. The fictional characters in the film and the very real Judy Garland, who was originally cast in it, were poorly watched and poorly protected and suffered as a result.

HF: Can you talk a bit about *Valley*?

SB: I found Judy Garland's wardrobe test for *Valley of the Dolls* when I was working as a designer for theater, and I was looking online for glamorous 1960s Hollywood costumes. The wardrobe test was a technical film, made to understand how to light her in those glitzy outfits. I don't know if you have ever watched *Valley of the Dolls*—it's such a bad movie and it seems to last forever. The story is about young, ambitious actresses who are completely destroyed by the entertainment world. When I came across the clip, I was struck by how Garland so poignantly and unintentionally performs the *Valley of the Dolls* story, and she does it economically, in less than five minutes.

Her personal story was the reason she was cast in the role in the first place. For years she had been addicted to drugs and alcohol and was undependable and impossible to work with. She was in bad shape. She got fired three days into the filming. All that is left of her participation in the film is this wardrobe test.

I have been working with actors for some years now and paying attention to how they perform, how they interpret, and how they filter information and emotion through their bodies and through their personalities. One of the things that I found compelling about this particular bit of film is that Garland has no script, so she's not really performing. You can feel how awkward and vulnerable she is, trying to make small talk with the crew. But, in fact, she is performing, because it was made when she was trying to convince everyone that she was hireable, that she'd be reliable, that she could be affable, crack jokes, be okay to work with. There's something that's so touching and so vulnerable about this performance that's not a real performance.

HF: What do you mean by "poorly watched" in Garland's case? By the movie studio? By her husbands?

SB: In her case, the "poorly watched" can be seen as ironic or it can be seen as literal. The movie studio, her mother and husbands, the camera, the crew, the world, her fans—they all watched her intently, avidly, and lovingly, but also with little concern for her actual well-being. So in that sense she was poorly watched. When she was a child star, she was exploited by her mother and the studio. Later it was the men in her life. She was poorly watched, poorly protected, and completely destroyed by it. A couple of years after the wardrobe test, her organs just collapsed. She died in her late forties.

HF: She's under the gaze of all these different viewers. Why did you ask the artists in *Valley* to reenact this one film test? What interests you in reenactment in general and the mediation of these performers in particular?

SB: I wanted to look at how a performance works—at how a performer interprets. For *Valley*, I asked eight strong women whose work I admire to re-create this particular wardrobe test—Anne Carson, Alicia Hall Moran, Deborah Hay, Joan Jonas, Tanya Selvaratnam, Kate Valk, Carrie Mae Weems, and Wendy Whelan. These women inhabit different disciplines in the creative arts, but they all engage with performance in some way in their work. With the help of The Fabric Workshop, I re-created the costumes in the original film clip and filmed the eight women reenacting it, in sync with the original and with each other. Then I projected their versions of the test, four on each side of the room. I was thinking of them as a Greek chorus commenting on Garland's life. By placing these eight very different performers side-by-side, synchronized, enacting the same material, you can clearly see their individual approaches—differences in

voice, movement, gestures—sometimes broad, sometimes minute. It opens up different readings, different emotional responses to the material.

I used the film clip as the script. The actors used Garland's text and gestures. I had a movement coach help them with the gestures, and they each had an in-ear monitor with Garland's voice on it so they could hear her timing and inflection. Everyone is wearing the same costumes, the lighting is the same—but if you watch the films individually, they are all completely different. Each performer interprets and filters the text through her own personality, her own body, her own being. It's amazing to watch.

HF: Can you say more about reenactment? It's not just actorly enhancement. There's an opening to difference—in an interview you once talked about "the enhanced Suzanne Bocanegra." I love that idea.

SB: Since 2010 I've been doing theater pieces that I call artist lectures. They are about my life and my work, and are structured in many ways like traditional artist slide lectures except I have an actor performing as me. I'm filtered through someone else's personality, and that changes and enhances what I have to say. Because it's done by someone else, it refocuses how we see the original.

I am onstage during these artist lectures, and there is always a tension between the real me and the actor playing me. In theater we know the actor isn't telling his or her own story, we know it's pretend, but we suspend that knowledge in order to watch and understand the show. In my pieces the relationship of whose story is authoritative turns inside out. It's staged in such a way that the differences between author and performer are on display and can be considered. Somewhere in every performance I mess up or the actor messes up and then I have to repeat something, and somehow the whole mechanism of storytelling gets revealed in those moments, which are never scripted or planned. They are often my favorite parts.

One thing I've learned is that really amazing performers have a gift. For example, the ballerina Wendy Whelan, who performs in *Valley*, knows instinctively how to move. And when I work with actors—people like Lili Taylor, Paul Lazar, Frances McDormand—they all have a natural ability to connect with the audience. I think it's something great actors are born with. You can train to be an actor, but I think certain people just have it, have it inside themselves. I find that incredible. In my artist lectures, I am performing on stage, and you see me delivering the text—blah, blah, blah, like I'm doing now—and simultaneously you see an actor transform that and really project it to the audience. I think that's a little miracle.

HF: In the description for *Valley*, you talk about the transformation of Judy Garland's fragility through the strength of these performances. You also

just mentioned that the performers function like a Greek chorus. A tragic figure is somehow redeemed—well, not exactly redeemed, but reclaimed for a community, even if that community is only posterity. There's a redemptive dimension in most of these pieces. In *Dialogue of the Carmelites*, which is based on Francis Poulenc's 1957 opera *Les Dialogues des Carmélites* about nuns who are sent to the guillotine during the French Revolution; in *Lemonade, Roses, Satchel* [2017, pp. 86–91], which is a beautiful ode to your grandmother; in *Valley* too: they're all women who have had a hard time, in one way or another, but they have been reclaimed by you. What is the attraction of stories of sacrifice and redemption for you? Do you see it as a persistent concern in your work?

SB: With the nuns, I really do, because I have this ambivalent relationship with the idea of becoming a nun. I've always been simultaneously attracted to and horrified by nuns. I grew up Catholic. I went to Catholic schools and I was taught by Dominican nuns in elementary school and Carmelite nuns in high school, some of whom were crazy and some of whom were wonderful. The nuns were the most exotic thing around in Pasadena, Texas, where I grew up. I saw them as independent women, working women, mysterious women of principle who sacrificed their lives to embrace an austere life of community for the idea of the church. Their outfits, though—the habits—weren't austere at all. They were based on garments from the twelfth century and were unbelievably beautiful and complicated. I wanted to be a nun for the longest time because of the habit. That's something that's always been a part of my life, circling around in my head.

On one hand the thought of becoming a cloistered nun was terrifying. When I was growing up, there was a girl down the street who was a few years older than me. She was the oldest in a family of eight kids. Right after she graduated from high school, she broke up with her boyfriend and entered a cloistered convent. Once you enter a cloister, you never come out of that building. Ever. Your family can visit and talk to you through a grate, but only on certain days. As a kid, I just couldn't get over that she did that. I still think about her and I wonder if she's still in that cloister. But then there's another side of me that thinks, "You're by yourself. No one bothers you. You just think your own thoughts all day. You sew or do some kind of craft to make money." Is that so bad? There is a part of me that can understand why somebody might be attracted to that kind of life.

HF: That sounds like life in the studio.

SB: Yeah. Except I can leave my studio, but a nun can never leave the cloister or at least is not supposed to. The girl down the street came from a big family that lived in a tiny house. I always wondered if maybe this was her way of getting some quiet and privacy. "Get me out of here. Even if it's a cloister, I'm out of here."

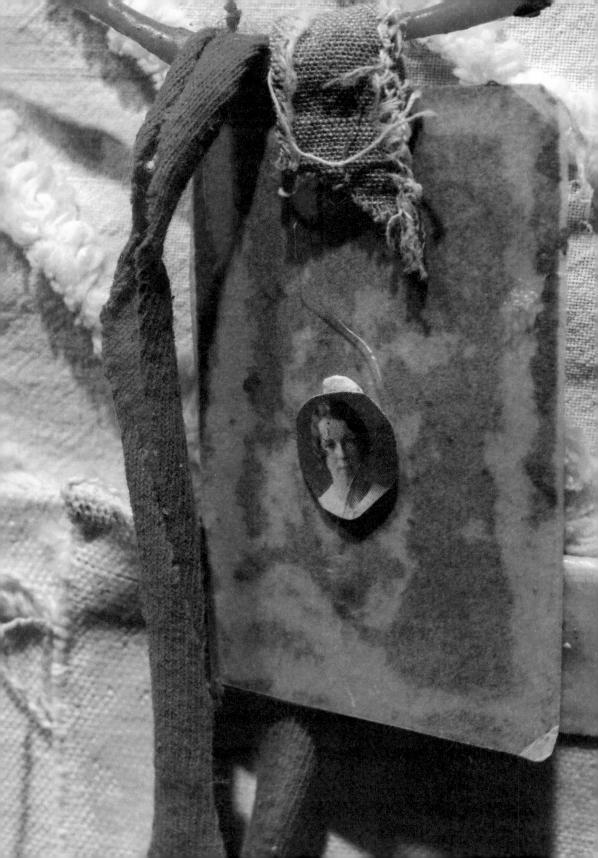

HF: Your mention of *Dialogue of the Carmelites* is an opportunity to ask you about your process. You're fascinated by nuns. Then what? How do you begin to work out the materials for a piece or a performance? It's somewhat archival in the sense that you begin to look for images, some drawn from your own family history. You look for books. You look on the internet.

SB: Years ago, I was surprised to discover that there are a lot of great operas about nuns. Before I started watching opera, I had always thought of it as all about messy romances with extravagantly costumed people falling in love and then killing themselves. But nuns and their stories figure in plenty of great operas— *Suor Angelica*, *Casanova*, *The Fiery Angel*. Of course, there's still murder and killing in those nun operas. *Dialogues des Carmélites*, in my opinion, is one of the better and more interesting operas about nuns. I've had it in my mind for a while that I would try to stage it somehow.

But everything really starts with me trying to pay attention to wherever my mind meanders. There are general things that interest me, subjects I never seem to get tired of, like nuns, like romantic ideas about nature and fantasies of the pastoral, like clothes and costume and how they communicate—just to name a few. Those general things that I like to think about lead me to more specific things, like the Poulenc opera.

Then I start circling around a subject and start gathering images and ideas. I go to libraries and walk down all the aisles and find books that have some sort of resonance with what I'm thinking about. Sometimes this process takes years. I have books and articles and images that I've collected and hung on to for so long. And then at a certain point it just finally all comes together.

HF: I know you use note cards—do you begin to juxtapose them and see how a work might take shape?

SB: I love index cards. I started using them years ago. My head always felt heavy— lots of different ideas all jumbled together. I couldn't sort out my ideas and build something with them. One day I wrote down every single thing I was interested in, that I was thinking about, that was floating aimlessly in my brain, on its own index card. A card catalog of myself. I've kept all those index cards, and I've added to them over the years.

Whenever I can't figure out where to go or what to think about or what I want my next piece to be, I just flip through the index cards. Once I figure out which index card I'm going to work on, that begins to generate a new set of index cards and leads to new books and new images. And then I allow myself to wander down whatever rabbit hole pops up. Sometimes, what I find down the rabbit hole becomes another card.

HF: But how do you find your way as you wander?

SB: I put all the cards on the wall, or I lay them on the floor and then I start to see if there's anything that connects to anything else. It's really collage. It's collaging ideas.

HF: That's how you work with images too?

SB: It's how I've always done my work. Years ago, in my studio I would just gather scraps of paper and stuff I found on the street and then start putting them together, trying to see if putting one thing next to some other thing makes it better or more interesting or more confusing.

HF: You are a visual artist, but you also have a strong impulse to tell a story. Is that what pushed you?

SB: I never think of myself as a storyteller. I always am surprised when I catch myself doing it.

HF: Well, you have a narrative drive. You want to connect the cards, to connect the dots. Is that what led you toward performance? Toward theater? Toward writing? Was that a difficult jump? Or was it a necessary one at a certain point?

SB: I find it so painful to write—it's just excruciating. I've always thought of myself as a terrible writer.

HF: Can I tell you a secret? Writing's hard for everybody.

SB: Even you?

HF: For writers especially.

SB: Well that makes me feel better! I started writing these stories in 2010 when Larry Kardish, who was at the time a senior curator in the film department at the Museum of Modern Art, asked me to do a slide lecture on my work. I thought that instead of just doing a regular slide lecture, I wanted to tell the story of how I became an artist, which involved my crazy Catholic church in Pasadena, Texas, and a scandal involving our priest and an artist. There was no other way to do that than to write it down.

HF: A male artist?

SB: Yes. It has to do with sex, but not the sex that's been in the news. It's a different kind.

HF: Speaking for the audience here, can I ask what kind of sex that is?

SB: Well, the name of the show is *When a Priest Marries a Witch* [2010].

HF: Oh.

SB: The title functions as a metaphor for most of the piece, but then at the end you find out it's literal.

 That was the first time I'd ever written something. And surprisingly, it worked. So I thought, well, I have two more stories about my life I want to tell, and those stories became my performances *Bodycast* [2013] and *Farmhouse/Whorehouse* [2017].

HF: Can you say a bit more about these two works?

SB: Well, it started like this. When I made *When a Priest Marries a Witch* I only knew

one actor, Paul Lazar, who is my best friend's husband. After I put my lecture together with all the slides and the story, I thought, "This is a real story, but I'm not a great storyteller. I need to get somebody who's a professional to do this." So, I called Paul and asked him if he would perform the lecture for me, and he said yes. He didn't have time to memorize it, so I recorded my talk and he put my voice in his ear, so he could repeat after me. Paul had done this before when he performed with The Wooster Group. I decided to put my voice in the hall on speakers, so you hear both of our voices at the same time. I was fascinated by how different his delivery was from mine and wanted to expose that.

It worked. Paul and I started doing it at theater festivals and galleries. We performed it in 2012 at Prelude, a little theater festival in New York City, and Frances McDormand and her husband Joel Coen saw it and loved it. They took Paul and me out for beers afterward. I don't know how I did this, but I had the chutzpah to say, "So Fran, I have part two of this piece, and it's about my teenage years." She said, "I'll do it." Then she looked at Paul, and said, "And you're going to direct." I didn't know her then—I didn't think she'd really do it, but she did.

HF: It was great.

SB: We rehearsed a lot. I had never rehearsed anything. I learned so much about theater from that process, through both Paul and Frances. I was shocked when, on our first day of rehearsal for *Bodycast*, they called my lecture a script and even more shocked when we sat down to do a table read.

HF: It's autobiographical, as you mentioned before.

SB: Yes. It's about a body cast that I wore as treatment for scoliosis for two years, from eighth grade into tenth grade, a time in your life when your body's changing so much. I don't think they do this anymore, but when I was a teenager, the way doctors straightened your spine was similar to how dentists straighten your teeth with braces. They would put my body on a rack to stretch my spine. Once I was stretched as much as possible, they wrapped my torso in a plaster cast to hold my spine in place. It was a very traumatic time for me. The cast really put a frame around my body changing.

HF: Aye yi yi.

SB: Every three months I'd get my cast replaced. Weirdly, the cast guy—the technician—would give me a different body each time. He would use a copper tool to shape the plaster, and sometimes he would give me breasts and make an hourglass figure, and sometimes he would make it completely flat, like a little girl. I was right in between both of those bodies. Every time I woke up, my body was different. It was so disorienting, and it was such a strange and awful thing to have this guy determine all that. At one point my mom decided she liked the womanly figure, so she would tell the guy, "I want the one with the figure."

HF: Oh my god.

SB: That was the outline for an essay or meditation on notions I grew up with about my body and about what a beautiful body was. It led me to thinking about the body in general, different definitions of beauty, which then led me to classical Greek and Roman sculpture. All of that got into *Bodycast*.

HF: The idea of "the constructed subject" was not just a theoretical idea for you; it was your actual experience.

SB: Yeah.

HF: What about *Farmhouse/Whorehouse*?

SB: That is my third artist lecture, and it is about my grandparents' farm in La Grange, Texas. When I was growing up I spent a lot of time on their farm, and because of those early memories I always loved the idea of farming, the idea of agriculture. I grew up in the 1960s and early 1970s, during the hippie era, and ideas about going back to the land were very much in the air. I thought the farm was magical, and I loved going there. My mom, who grew up on it, would always say, "Are you nuts? It's backbreaking work. It's boring, it's repetitive, it's 24/7, it's lonely." She and her siblings got off the farm as soon as they could. I would try to argue with her—"Oh, but the fields and the sunrise, watching things grow." But I believed my mom too—obviously, I'm not a farmer now. I do like to ruminate on these ideas that somehow got inside me. I like how contradictory they can be. I'm also always surprised to find how embedded they are in our culture and history. I certainly didn't invent them.

HF: Right. The farmhouse is across the street from a whorehouse. For every moment of pastoralism in your work, there's also an underside, a dark world. *Lemonade, Roses, Satchel*, the beautiful ode to your grandmother, reads a little satirically too. She's this crazy goddess of agriculture. You have both sides again—it's similar to your relationship to the Catholic Church, one of intense ambivalence.

SB: Yeah, exactly. But those subjects are so interesting to me because they go back and forth.

HF: Good angel, bad angel.

SB: Right. With *Farmhouse/Whorehouse*, I was curious about the juxtaposition of these two ways of life occurring side-by-side. Here's a typical small, Texas farm, tended by a quiet, churchgoing couple. They lived a simple, hardscrabble life. And then across the road was a notorious whorehouse, the Chicken Ranch. It was famous in Texas, but then it became more famous as a Broadway musical and movie, *The Best Little Whorehouse In Texas*. I didn't figure out what made the juxtaposition of my grandparents' farm and the whorehouse interesting until I started writing the piece. It was really just a hunch.

HF: All these pieces are not only personal stories; they're also cultural essays.

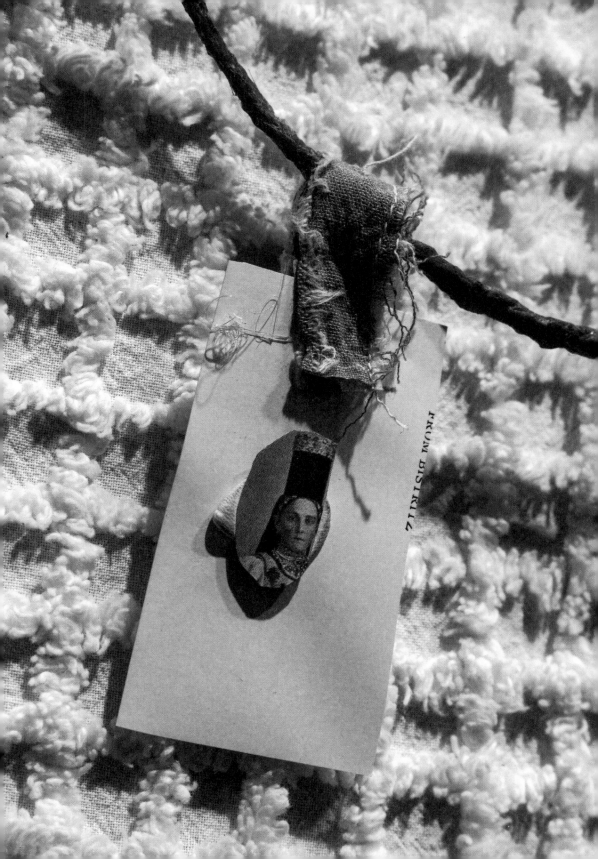

This is what I mean by the archival dimension of your work. You really explore a subject. It might begin with your story, but it quickly opens up into history somehow.

SB: One of the things I started thinking about when I started working on *Farmhouse/Whorehouse* was that my introduction to art was through the French Impressionists. When I was a girl I loved Renoir's soft, fuzzy paintings of pretty women. I loved Degas because he painted ballerinas, and I loved ballerinas. It wasn't until much later that I realized I had an idealized, completely inaccurate view of the women in these paintings. Those dancers had nothing in common with me and my friends going to ballet lessons in our tutus in the suburbs. Many, if not most of the artists' models were prostitutes. These were working girls with a really hard life. That led me to think about how *The Best Little Whorehouse in Texas* romanticizes the lives of the women at the Chicken Ranch. In the movie they are portrayed as having such a great time—it looks like fun. But it was isolating, hard work. These were poor women who had no place else to go.

HF: Any lessons learned from your own loft stage?

SB: It has been a real revelation to have a theater in my loft. I learned how to be a producer—how to schedule, how to budget, how to develop an audience, all the structural things I never considered before, but are essential to how a piece works in real time. It helped me understand what an audience does and how an audience participates.

HF: Maybe this is the moment to ask about the feminist dimension in your work. You talked about your own experience in *Bodycast*, and just now about women in historically subordinate positions. Do you think consciously about this dimension of your work? Or is it just native to your experience?

SB: When I was in high school *Our Bodies, Ourselves* was published, and my best friend Josephine started carrying it around saying, "This is my Bible." I remember being shocked by everything I read in it, but it made such complete sense. We all became feminists. I stopped shaving my legs—my dad refused to let me out of the house for a while. It seems crazy now, that shaving your legs was such a big deal. For me and my friends, feminism became a way we began to interpret the world. But we didn't get feminist ideas from our families or from our relatives. We got them from television, magazines, and books. It was imported to us. That's the soil that all my thinking grew up in and that was absolutely not the soil my mother grew up in.

HF: It seems to me that there's a play, from the beginning of your practice, between textile and text. You make costumes—some of which are components of *La Fille*—and you talk about them in terms of writing. You say that "they have

an argument." Can you talk a little about the relation between textile and text in your work? You mentioned earlier that you worked as a collagist and how that led to note cards and a way to write.

SB: Well, we all "read" clothing. You can look at everyone in this audience and get an idea of who they are by just dissecting these pants, those shoes, that color. One of the things you think about when you're designing costumes for theater is who the character is and what the play is about, and how the costumes reveal that and add to that or sometimes even counter that. Costumes get really interesting to me when they become a commentary on the text of the play, when they add another dimension, when they offer up another reading.

I don't know how this relates, but your question reminded me of all the time I spent in fabric stores with my mother. Mom sewed like crazy. I had a new dress every single week. She was very connected to textiles, although no one called them textiles. Fabric stores were like museums to me now—I would wander through all the aisles, looking hard and considering each bolt. That was my introduction to looking at things.

HF: I'm interested in your "in-betweenness": between black box and white cube, between personal story and cultural history, and of course between art forms. Are you influenced by or do you have affinities with Spalding Gray, Laurie Anderson, Richard Foreman?

SB: I love all those people, but I think the question is larger than what I get as an artist from looking at theater. I think there is a tremendous amount of strangeness and energy you can generate when you flip from one way of making work to another. Not just visual art and theater, but any different modes of working. When you force these ways of working to rub up against each other they can spark, and I am always searching for places where I can make that spark happen.

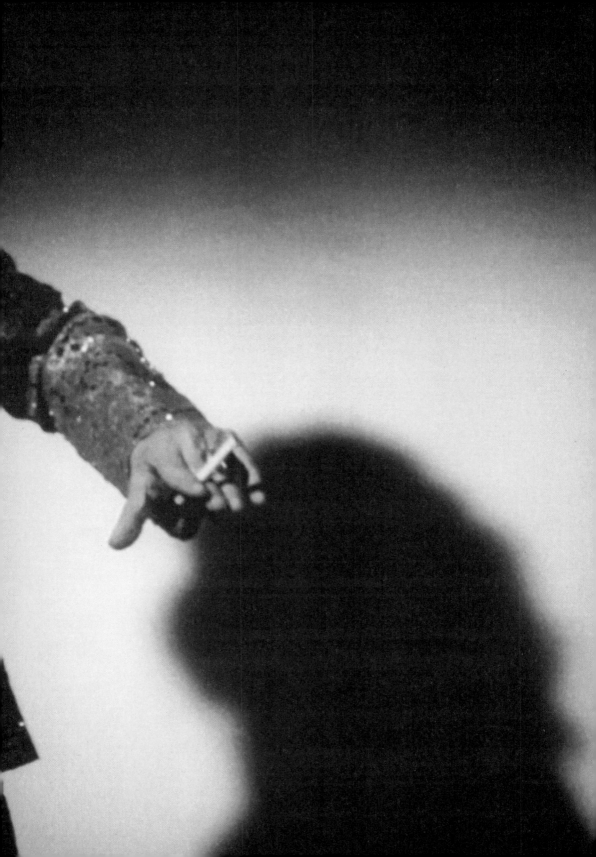

Valley

In 1967 Judy Garland was cast in the film *Valley of the Dolls*, a story of three women undone by drugs and stardom on Broadway in the 1960s. A preternaturally versatile and gifted performer, Garland had been exploited by the entertainment industry from the time she was a young girl. When she was chosen to play one of the leading roles in *Valley of the Dolls*, she was known to be unpredictable and painfully fragile. She was fired soon after work on the film began.

Some of the footage that remains of her participation in it are her wardrobe tests, in which she models her costumes for the film. The tests have no script, no scenario, no song. The movements and nervous chatter are her own. Garland had performed professionally from the age of two, yet in this footage she appears self-conscious and uncomfortable. Her awkwardness and vulnerability make the clips feel authentic and heartbreaking.

Suzanne Bocanegra re-created this footage, casting eight women artists whose work she admires in the role of Garland. Performing in *Valley* are poet Anne Carson, choreographer and dancer Deborah Hay, artist Joan Jonas, singer and actor Alicia Hall Moran, actor and activist Tanya Selvaratnam, actor Kate Valk, artist Carrie Mae Weems, and ballerina Wendy Whelan. Each of them reenacts Garland's gestures and words, while wearing replicas of the four garments the actress wore in the wardrobe tests. They form a sort of Greek chorus, embodying and commenting on her talent and her plight.

Valley, 2018. Eight-channel HD video (color, sound). 4:44 minutes. In collaboration with The Fabric Workshop and Museum, Philadelphia

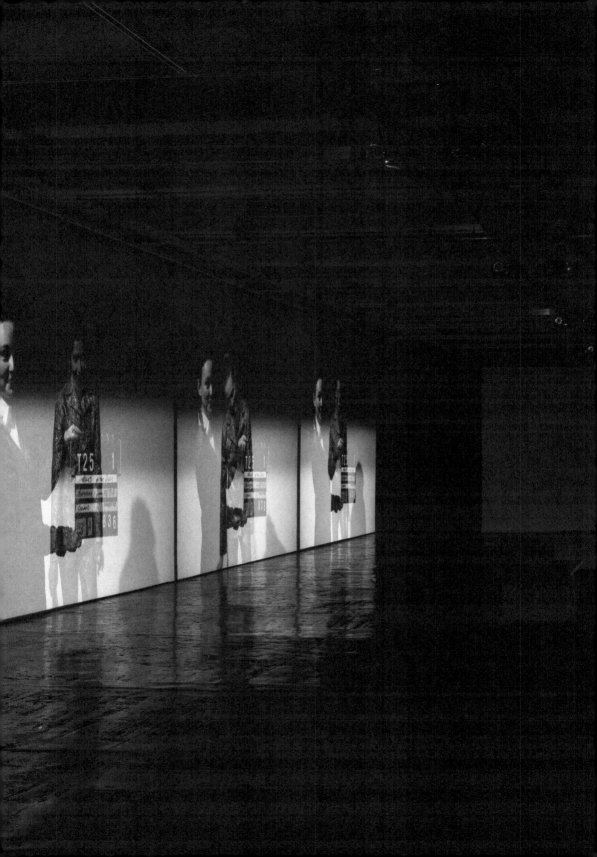

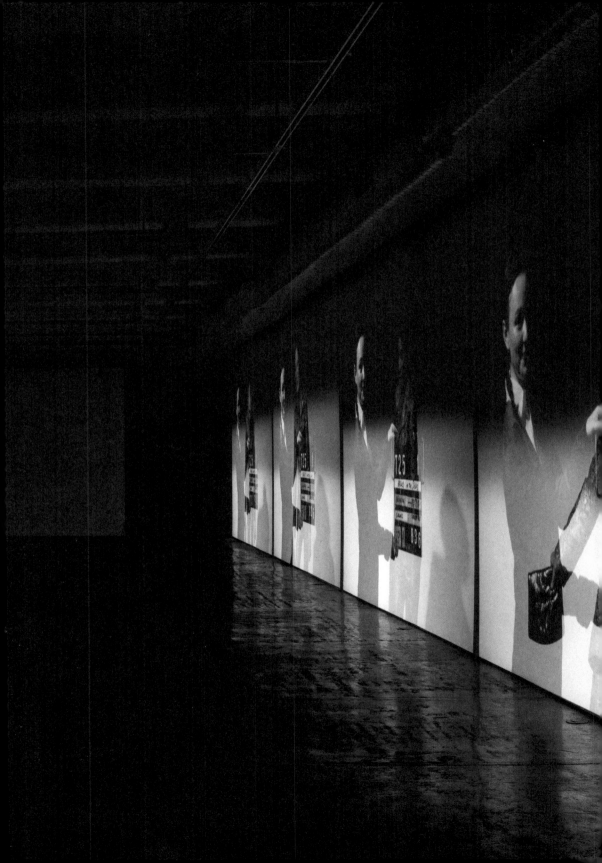

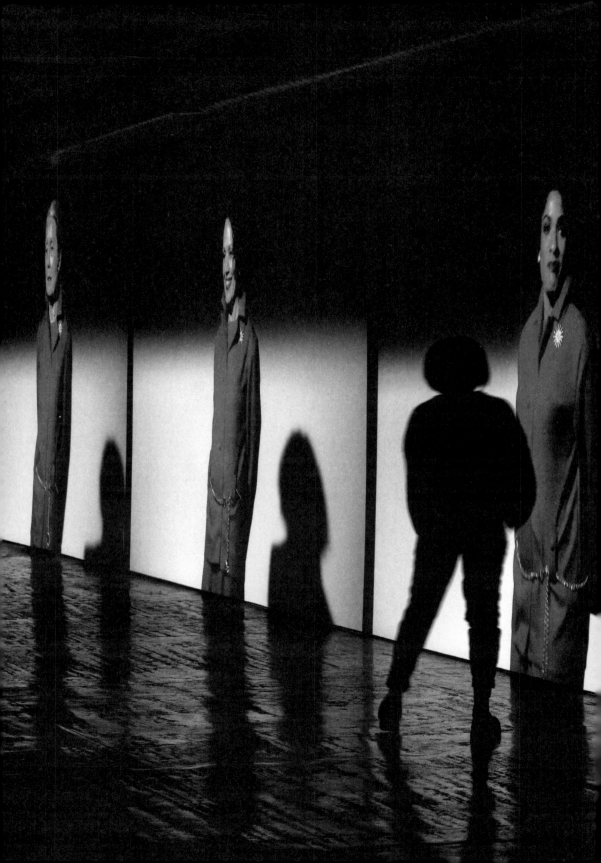

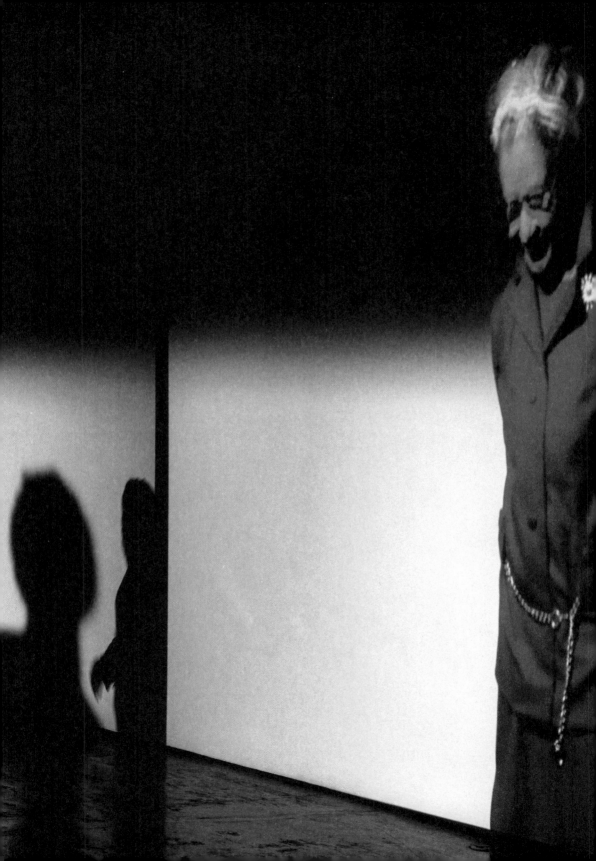

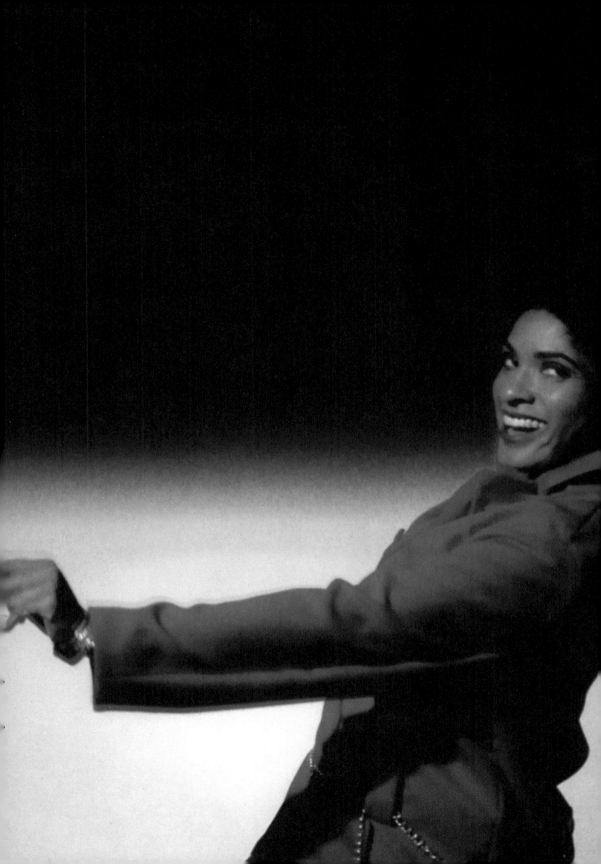

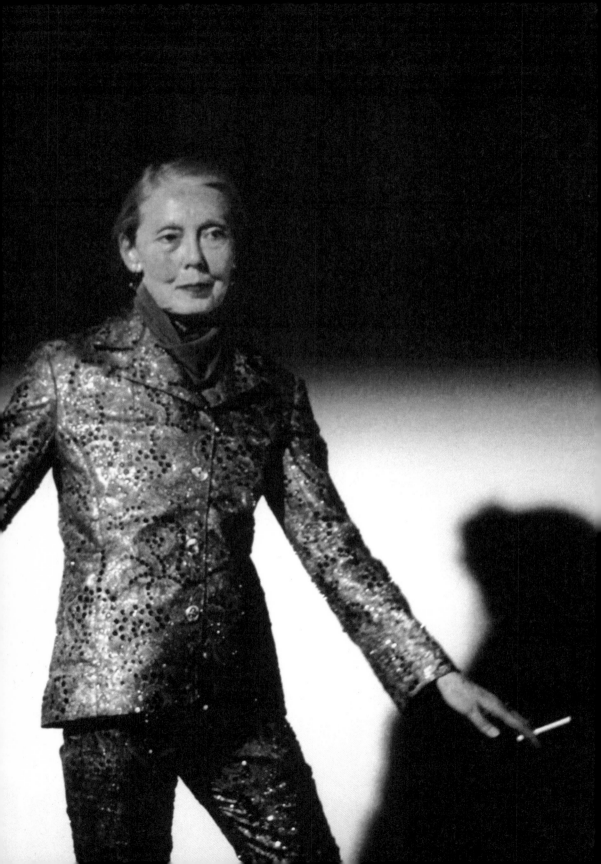

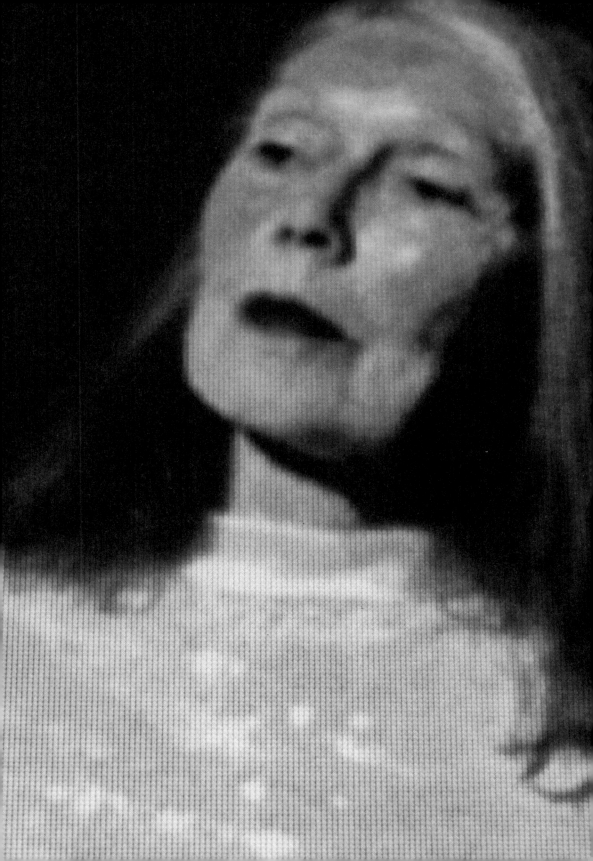

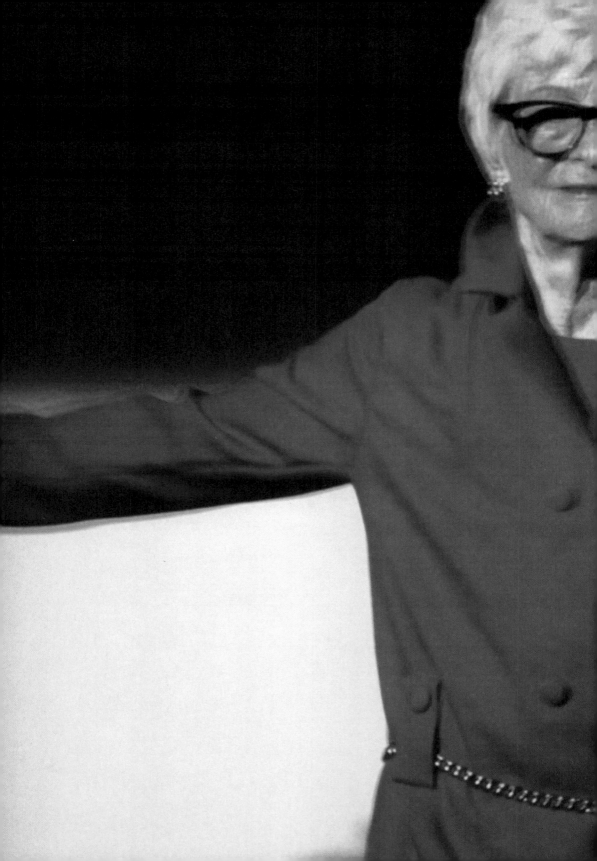

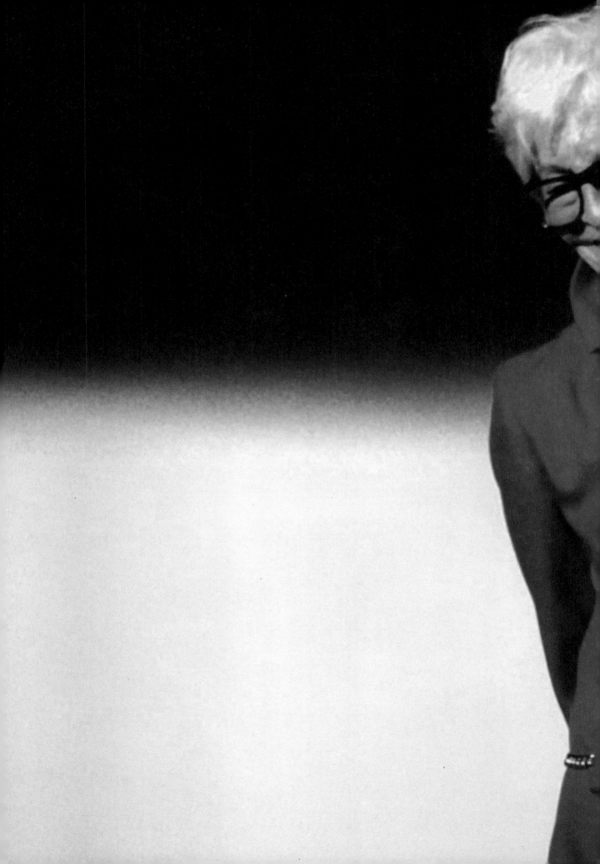

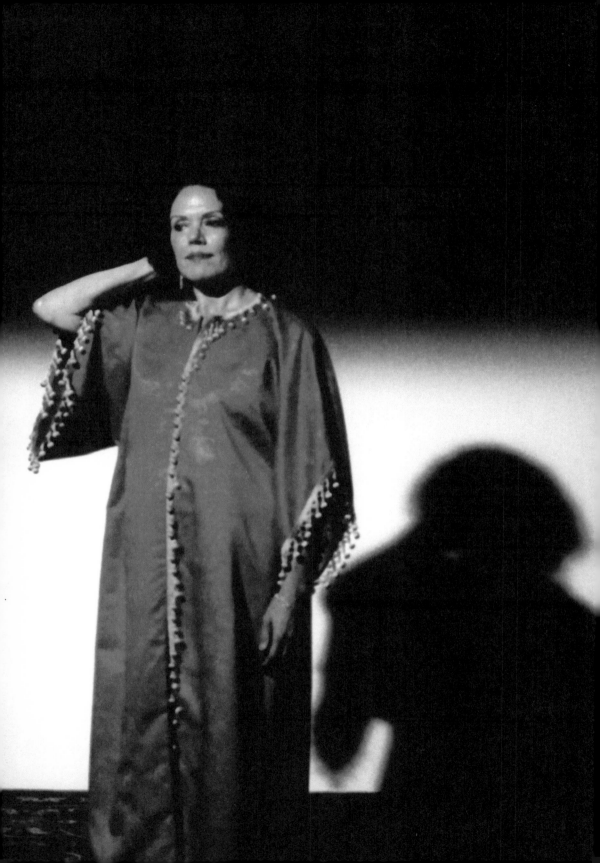

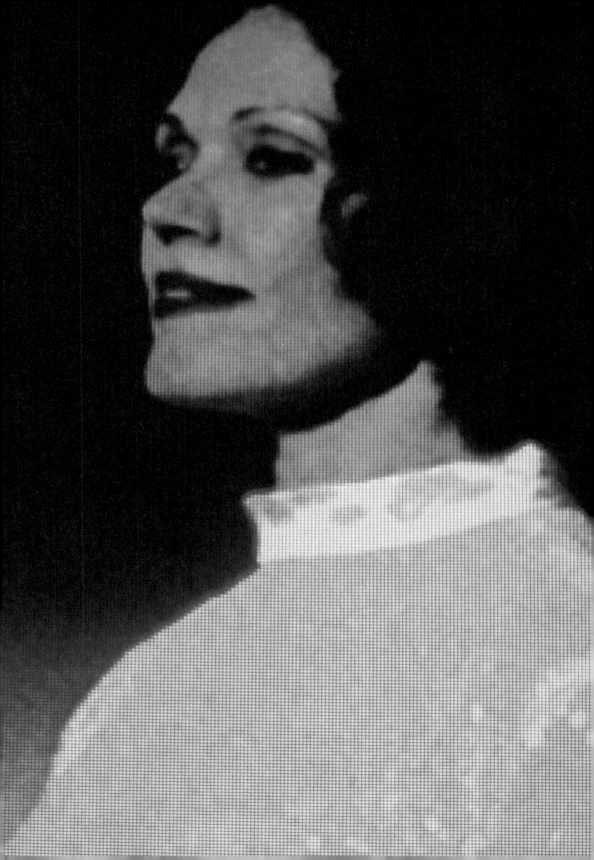

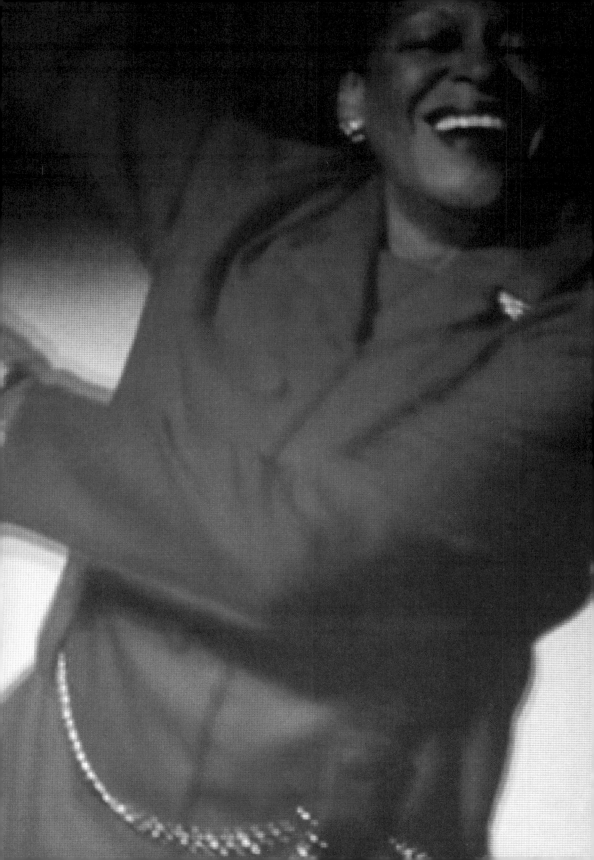

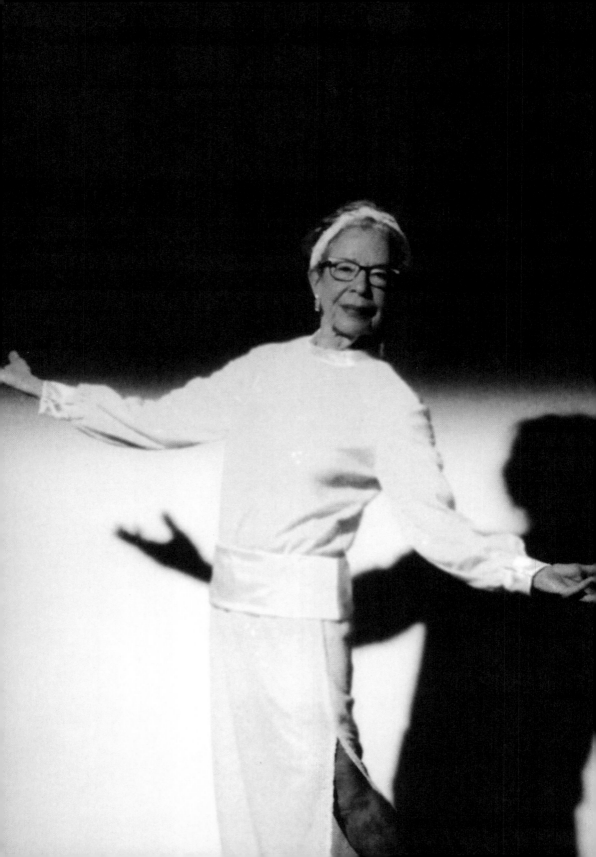

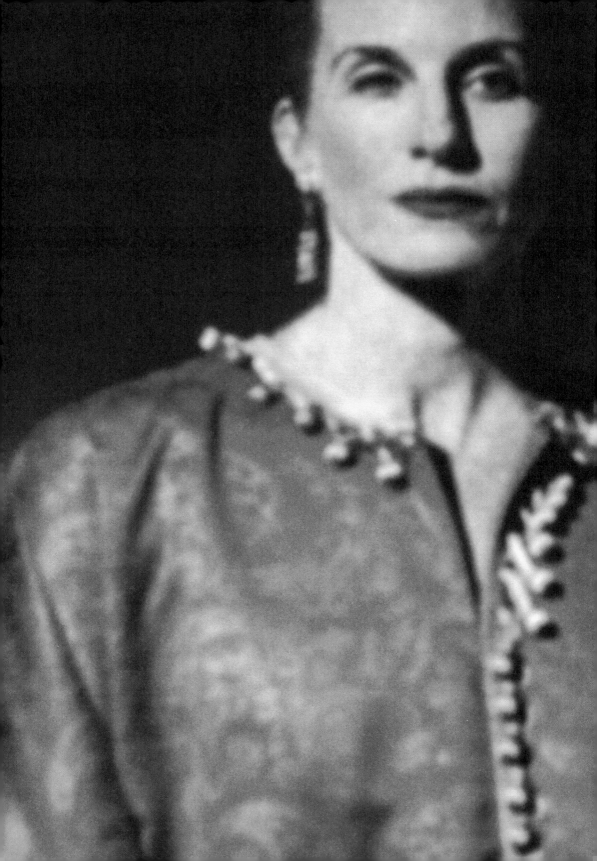

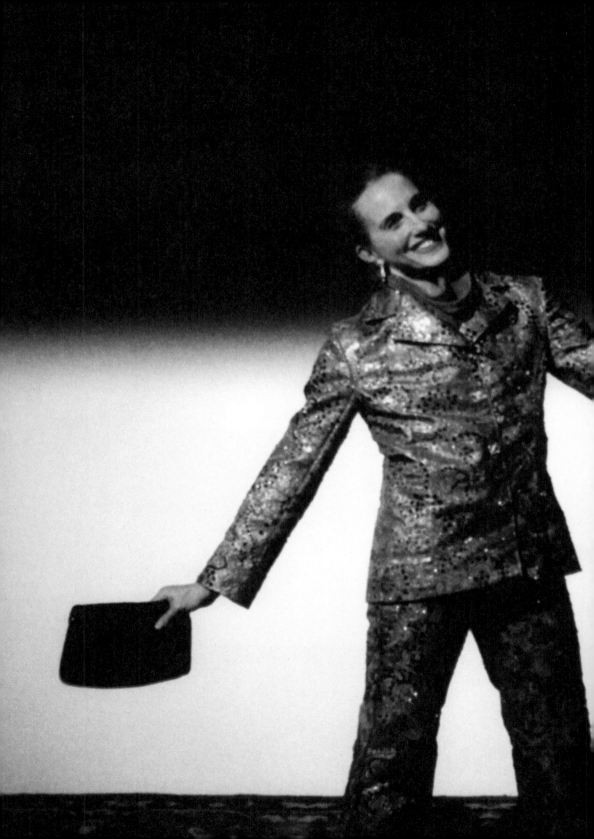

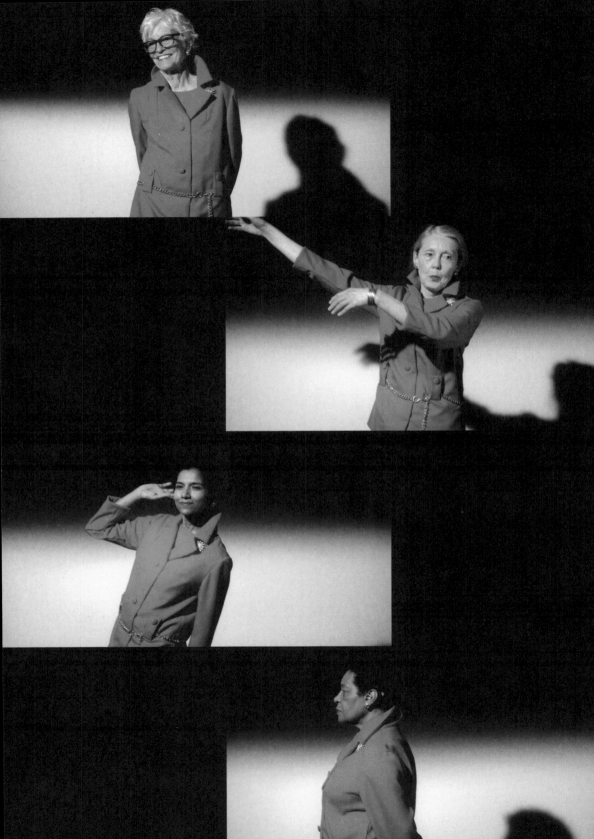

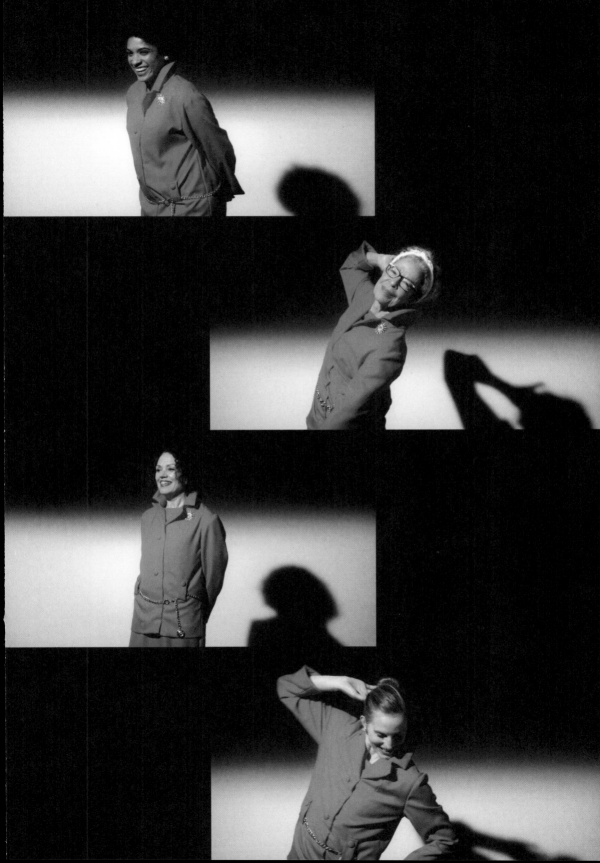

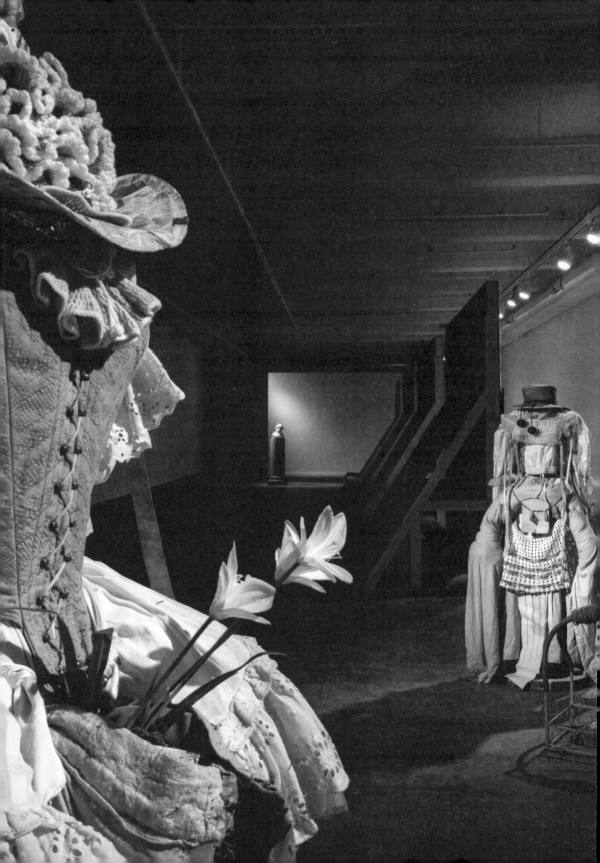

La Fille

First performed in France in 1789, *La Fille mal gardée* is one of the oldest classical ballets that is still part of the modern repertory. In English it is often called "The Wayward Daughter," but a more literal translation is "The Poorly Watched Girl." The ballet is a comedic pastiche of country dances and folk tunes about a peasant girl who falls in love with a young man, but her widowed mother is intent on marrying her off to a wealthier suitor. It is set in stereotypical pastoral locations—a lively barnyard, a quaint cottage, picturesque fields. Frederick Ashton's 1960s staging of this ballet even included ballerinas dancing *en pointe* in wooden clogs.

The "watching" in the title has several meanings. "La Fille" gets into trouble—caught with her beloved on the day she is to marry the rich man—because she is poorly watched by her mother. Her character also represents an idealized rural trope, watched voyeuristically for the entertainment of an upper-class, urban audience.

In his 1972 essay "The Diseases of Costume," Roland Barthes posits theatrical costume as "a kind of writing and has the ambiguity of writing, an instrument in the service of a purpose which transcends it." Through the use of costumes and scenography, Suzanne Bocanegra stages her own response to the fantasy of a romantic agricultural idyll and the watching of this girl.

La Fille, 2018. Mixed media. Dimensions variable. In collaboration with The Fabric Workshop and Museum, Philadelphia

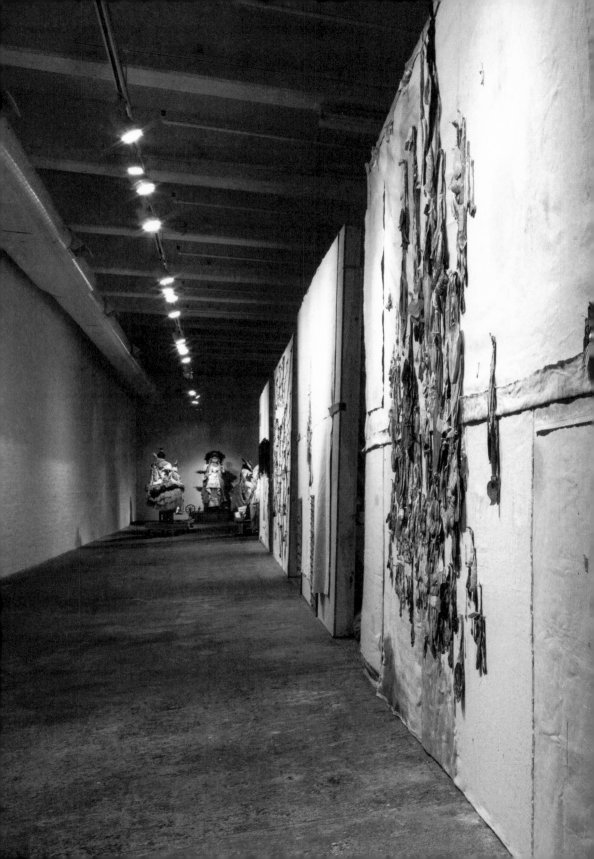

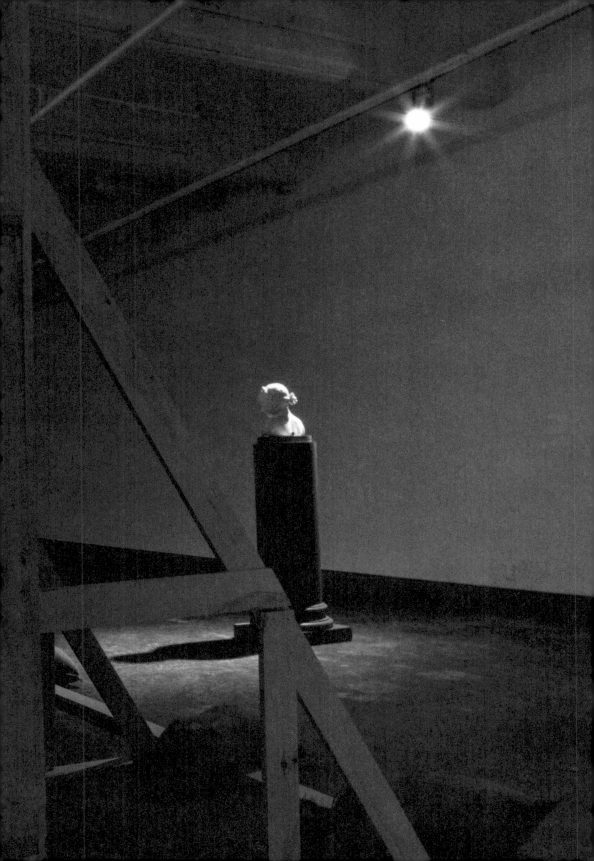

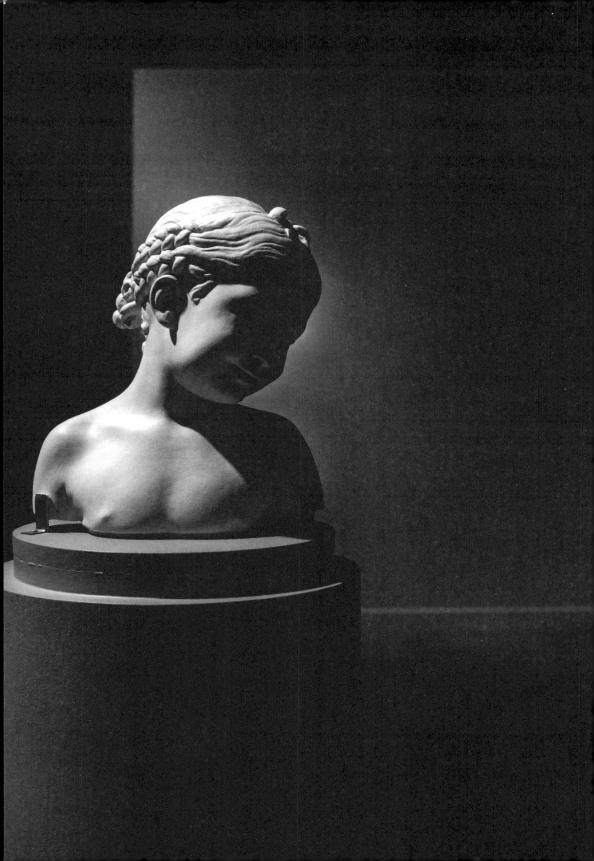

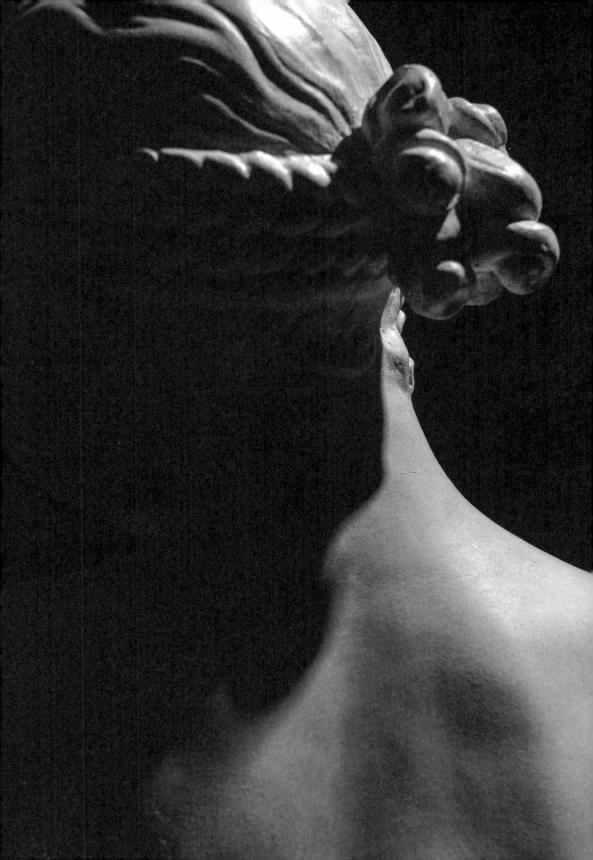

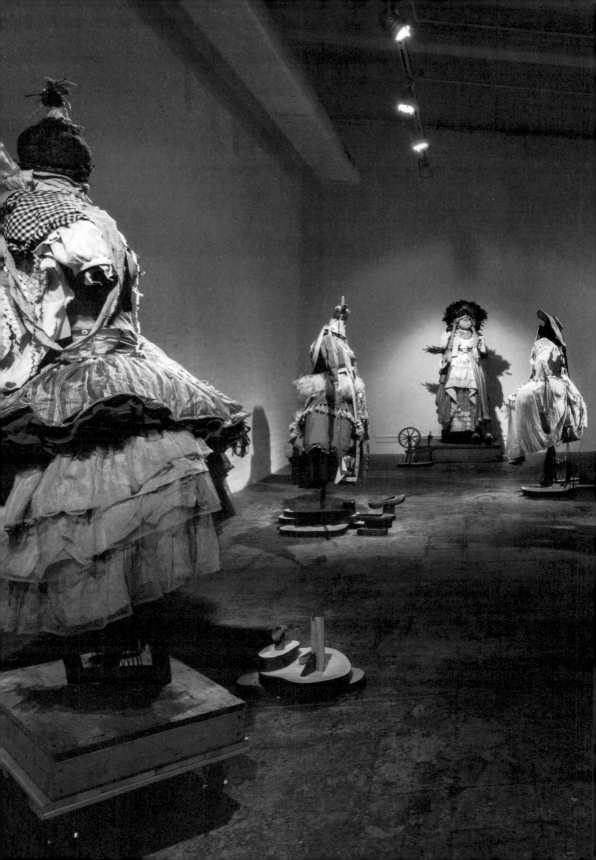

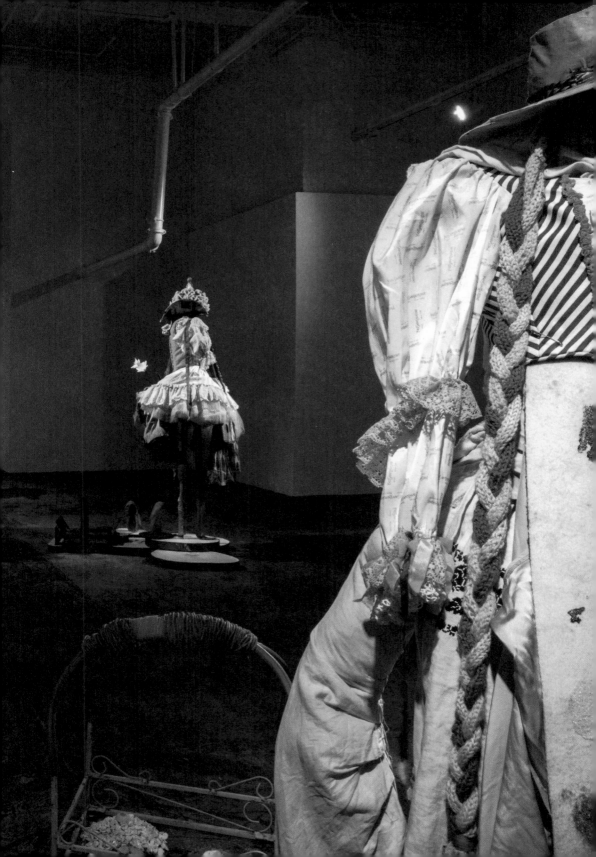

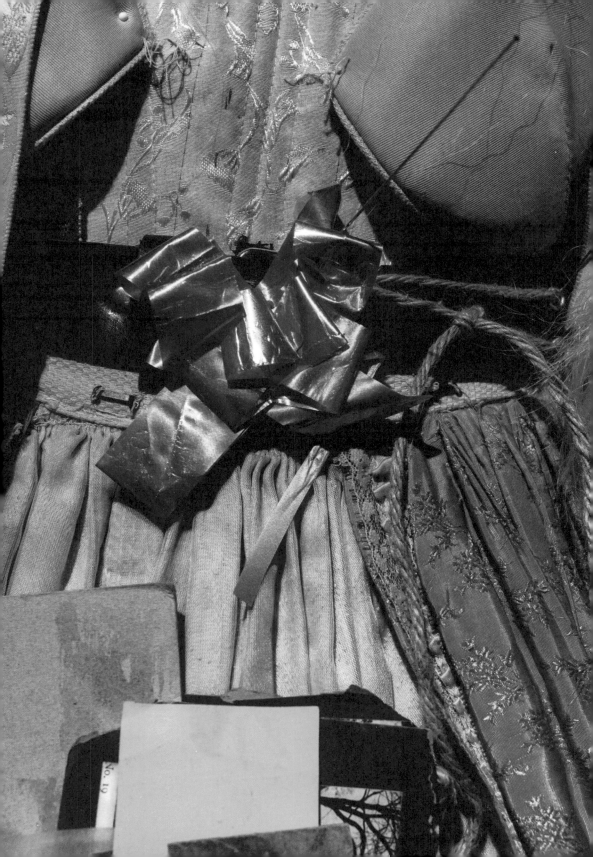

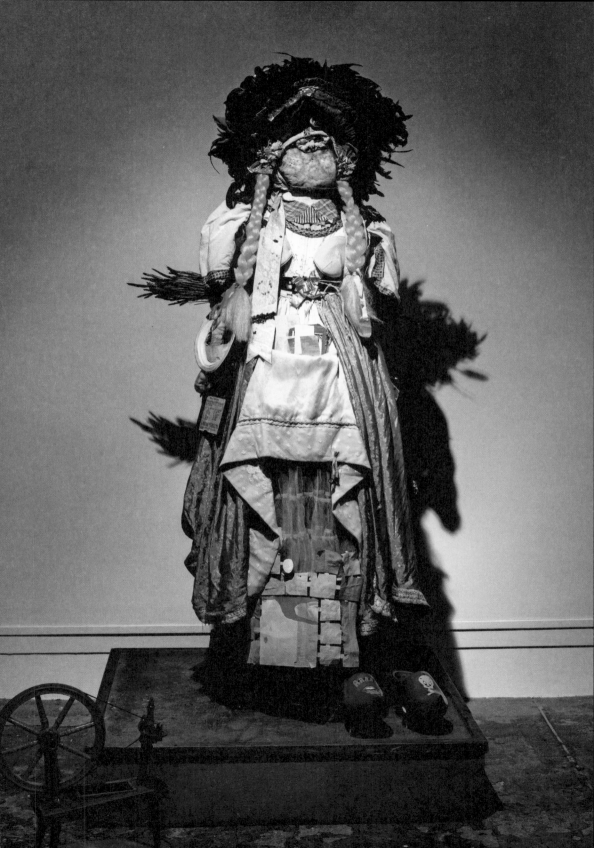

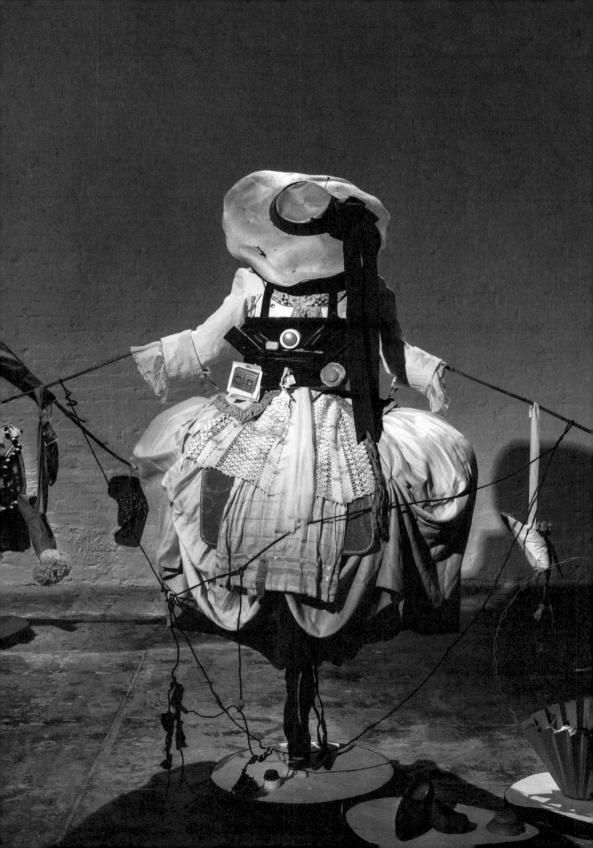

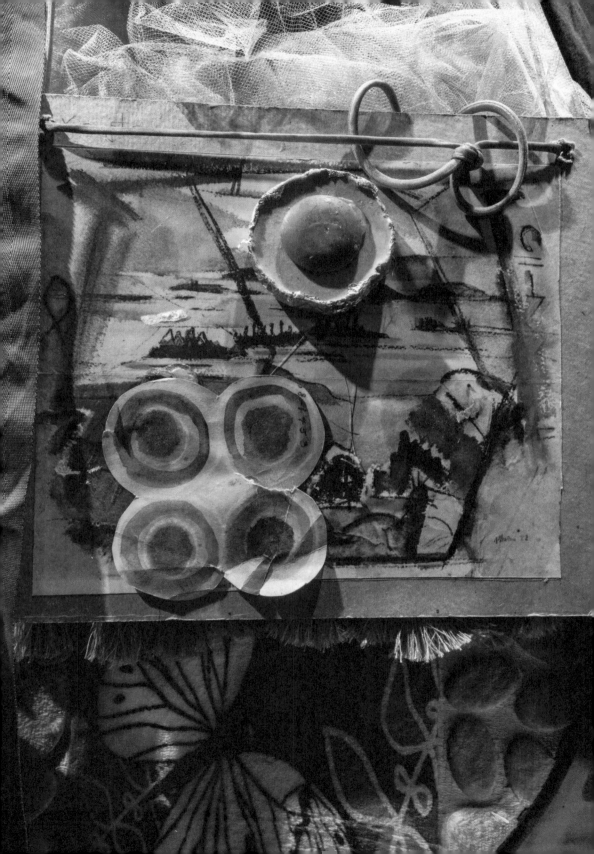

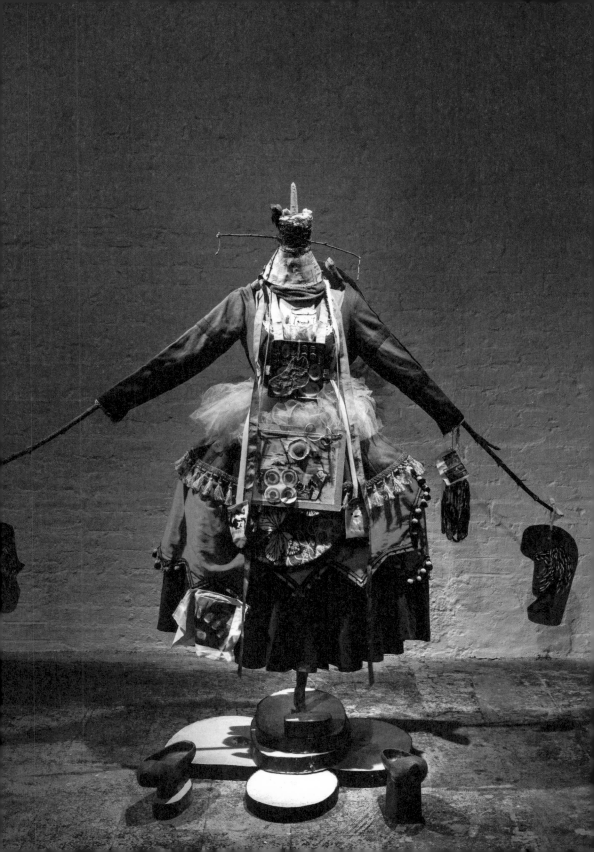

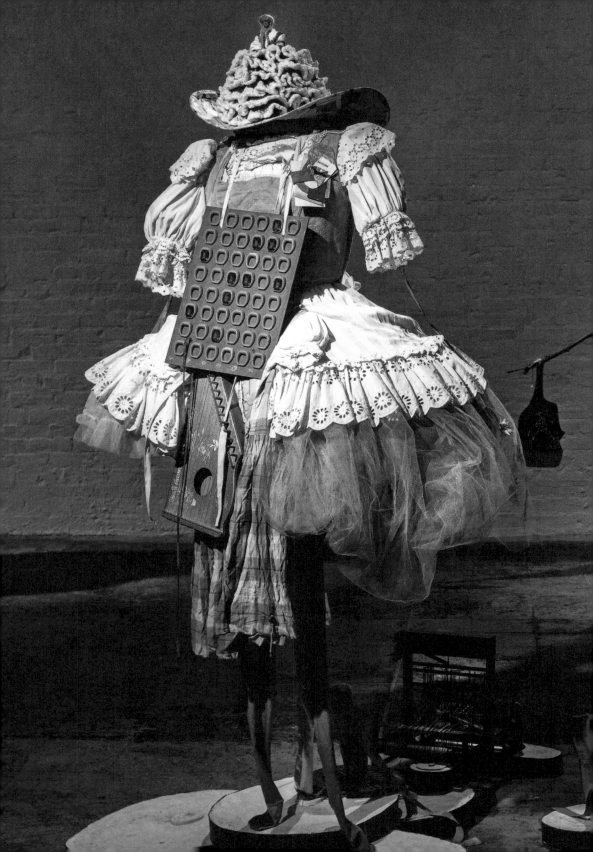

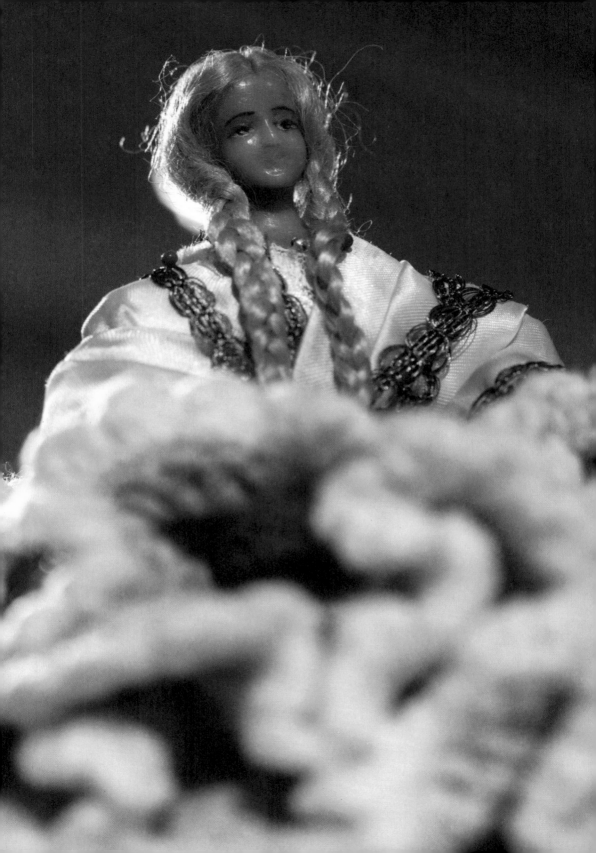

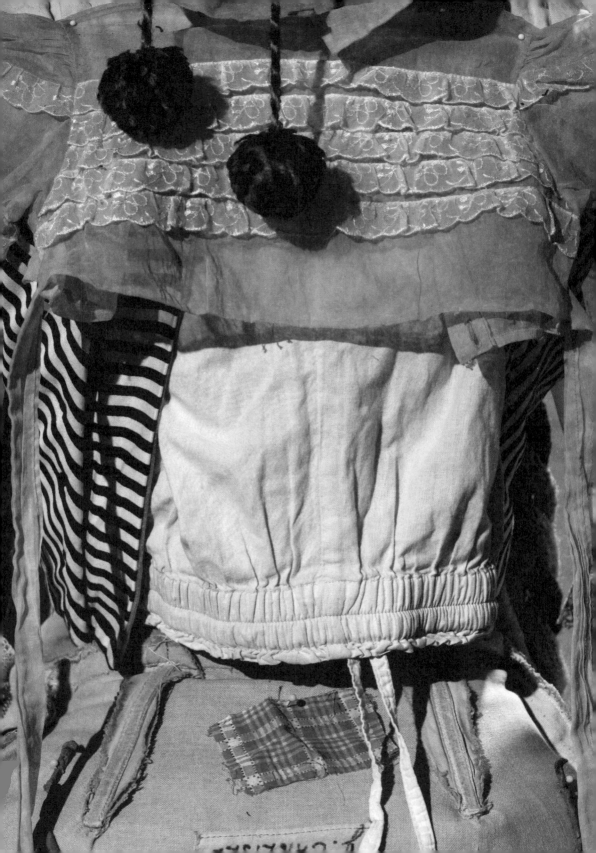

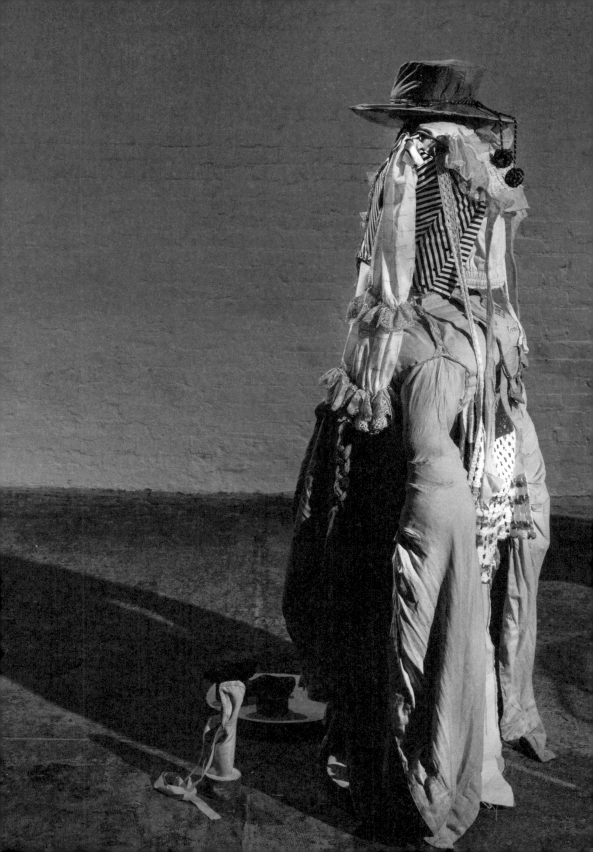

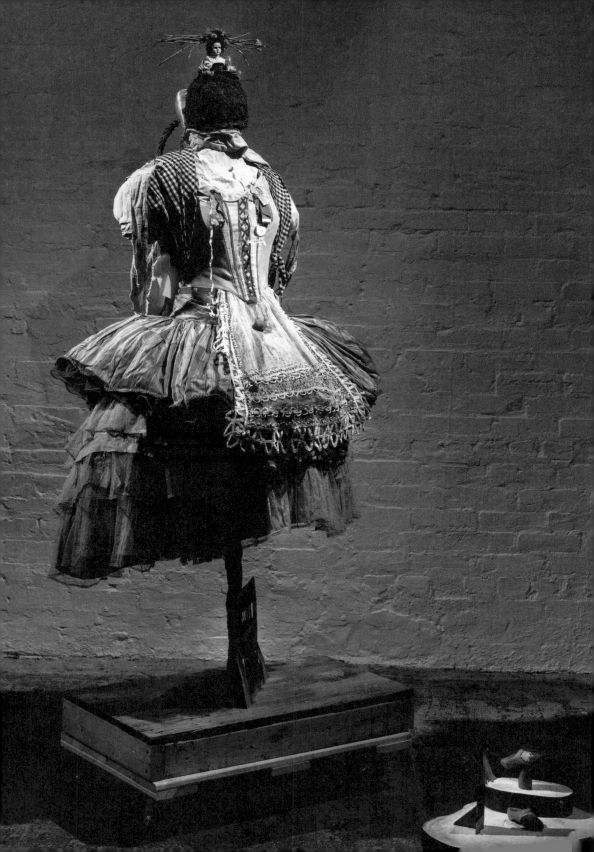

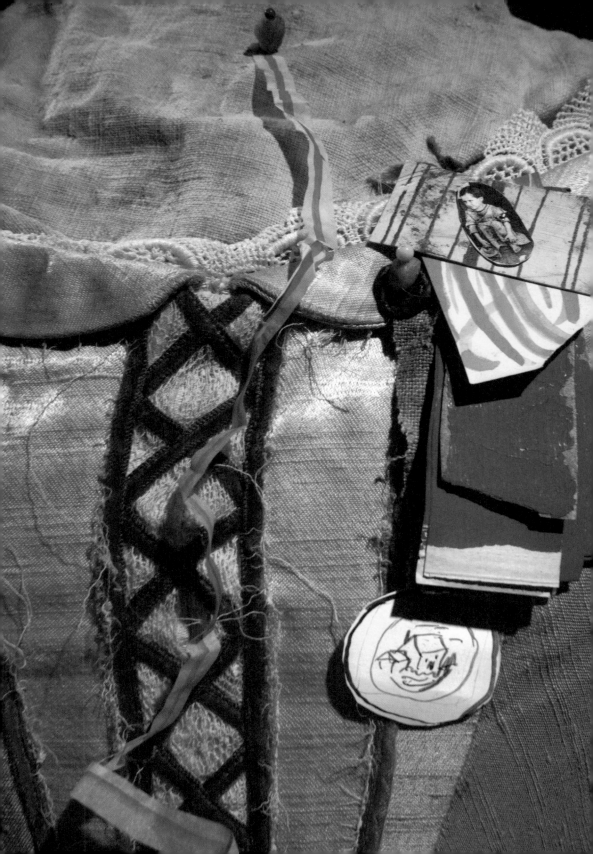

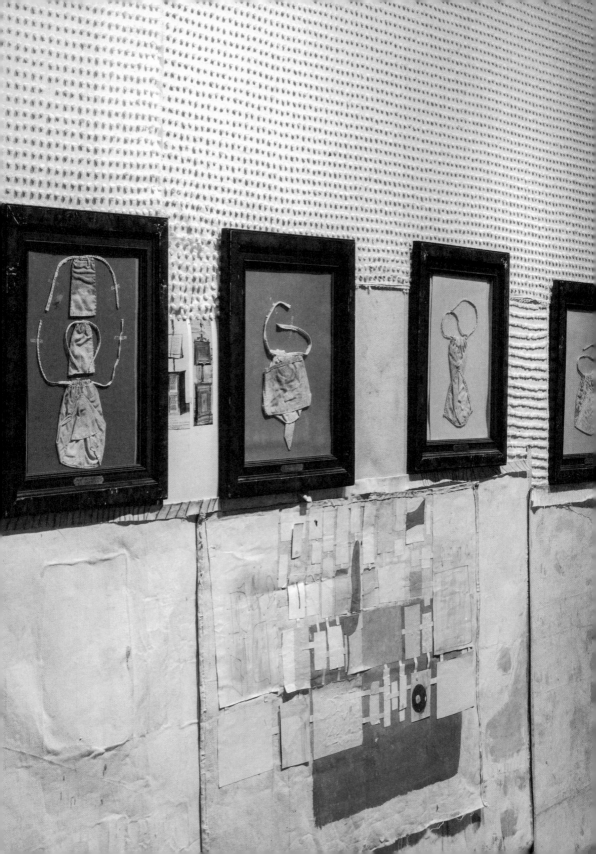

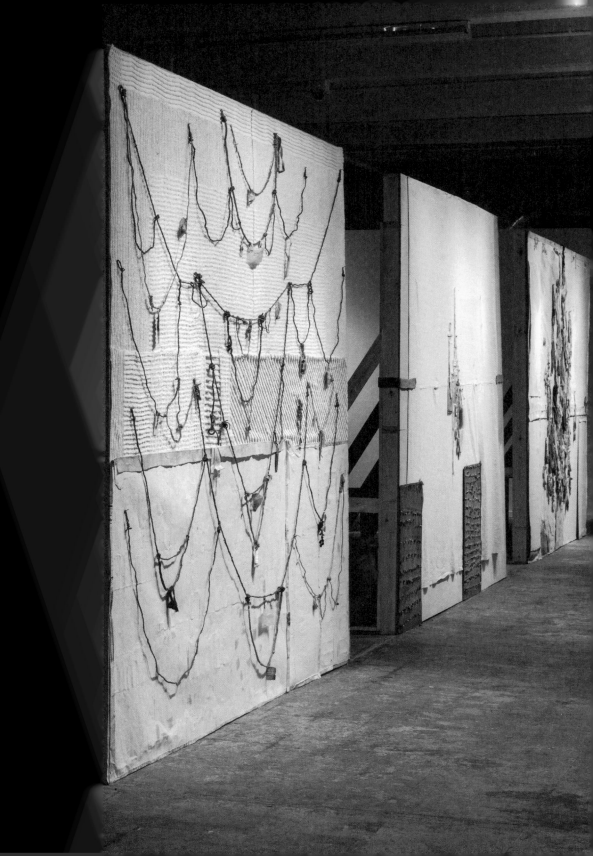

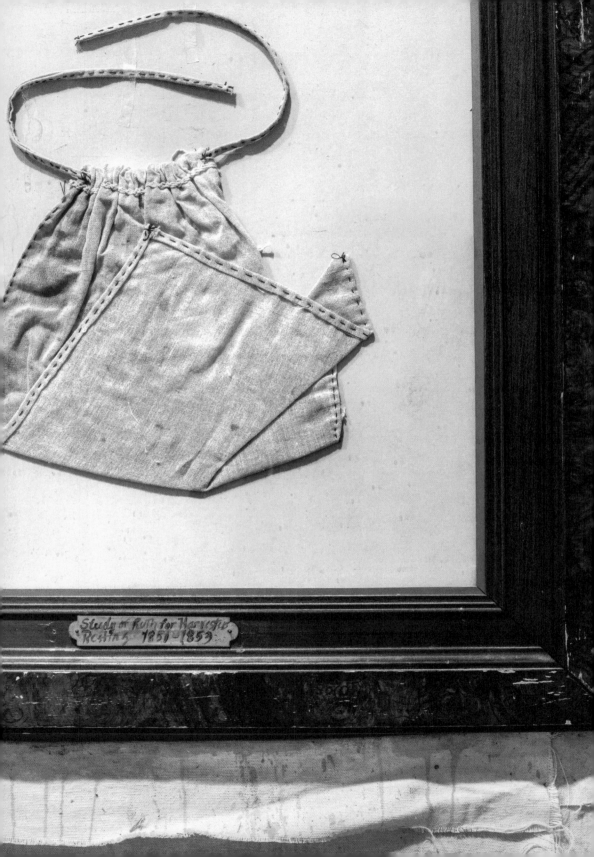

Study of Ruth for Harvesto
Ruskin 1851–1853

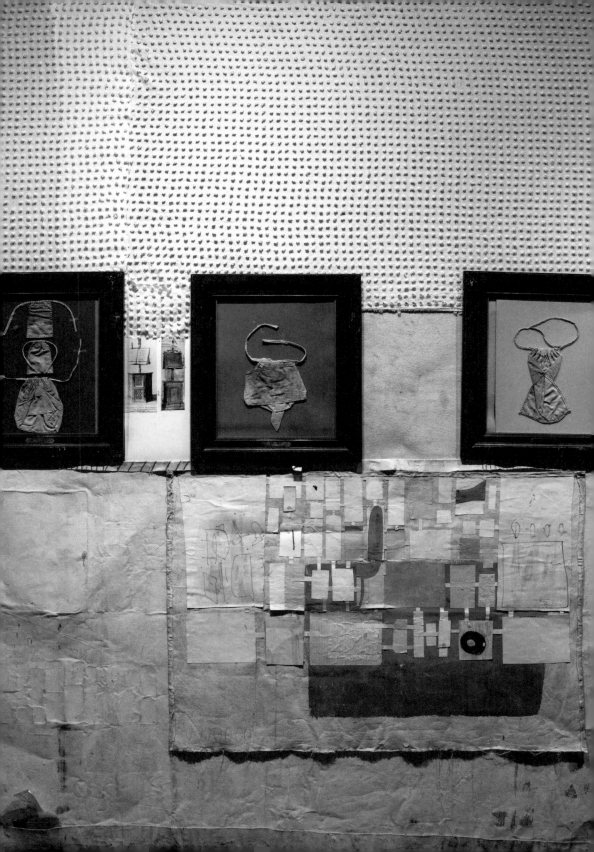

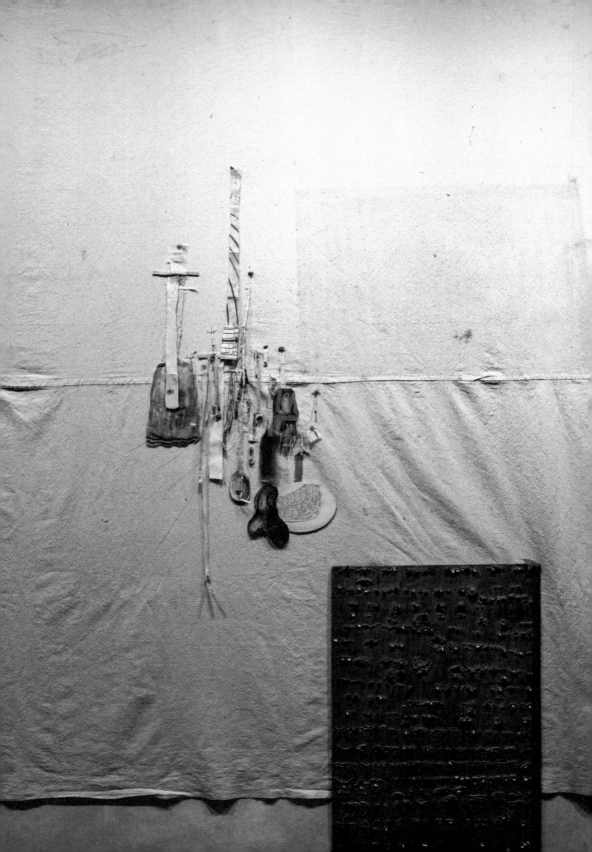

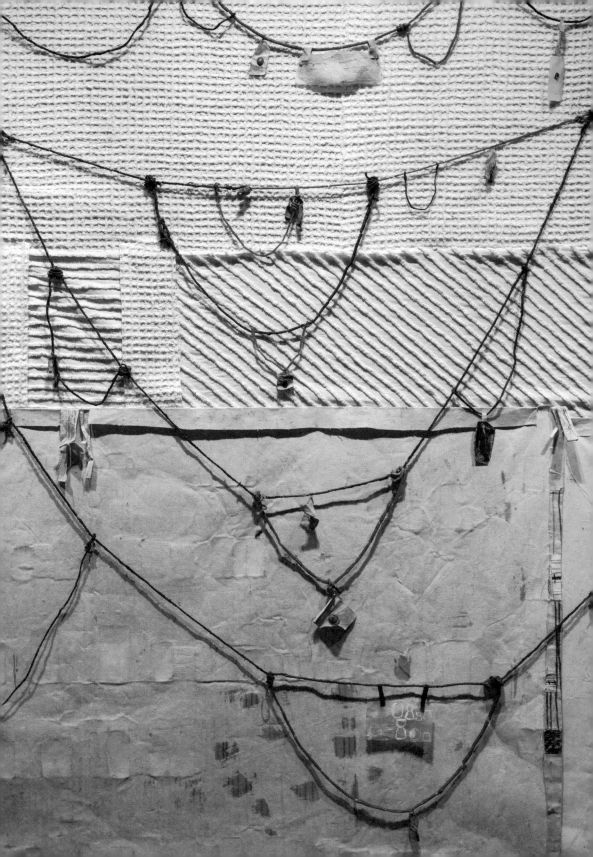

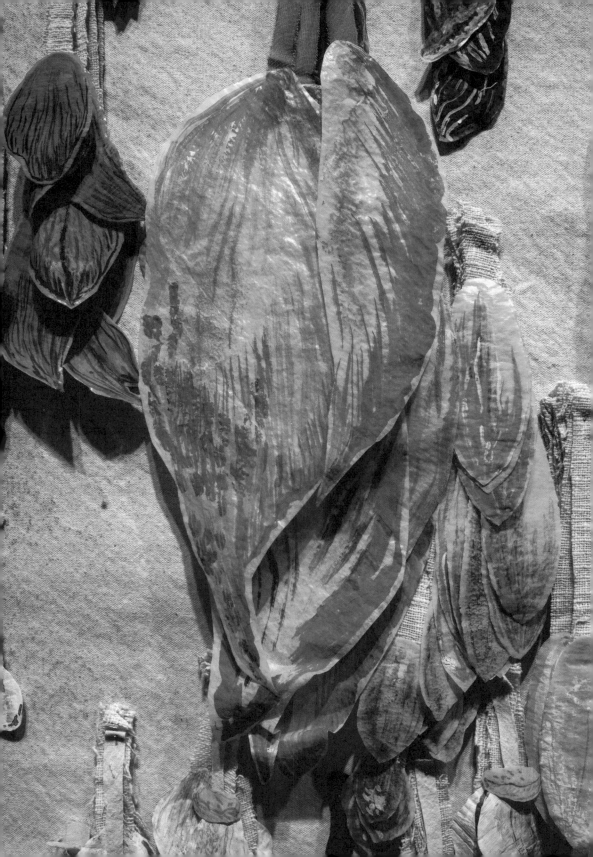

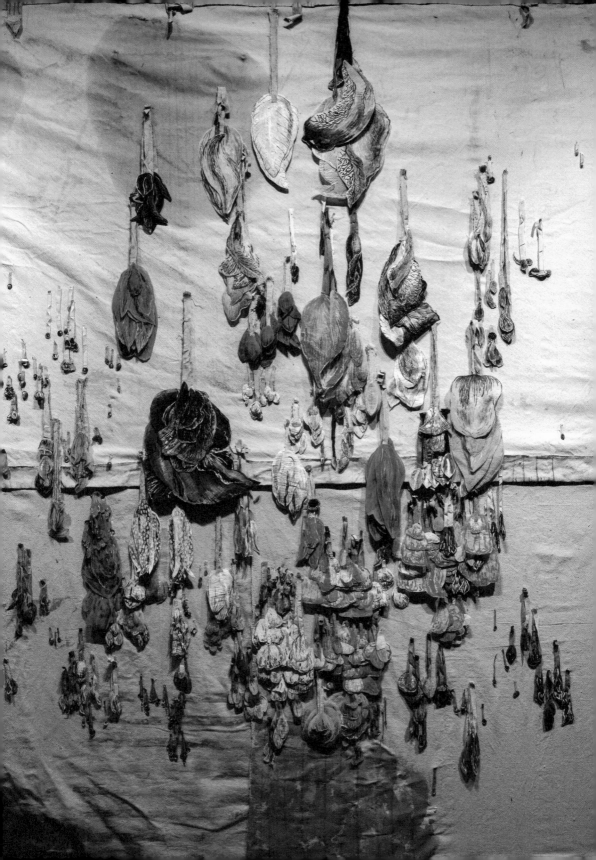

Dialogue of the Carmelites

In 1957 Francis Poulenc completed the opera *Les Dialogues des Carmélites*. He based it on the play of the same tittle written in 1949 by Georges Bernanos, whose inspiration was the true story of a convent of Carmelite nuns executed in Paris during the waning days of the Reign of Terror, one of the most violent periods of the French Revolution.

Suzanne Bocanegra staged her own novel version of this opera, casting the nuns photographed for the *Guide to the Catholic Sisterhoods in the United States*. The second edition of this book was published in 1953, the same year Poulenc began to write his opera. The guide reveals the Catholic Church's ideas about women and devotion in the middle of the twentieth century. Each page lists a particular order's purpose, its history, its requirements for admission, as well as a description of the order's habit.

Bocanegra embroidered the photographs of the nuns, alluding to the way that cloistered nuns have embellished the pages of their prayer books with hand stitching throughout the centuries. Bocanegra's pages are arrayed side-by-side on a shelf spanning all four gallery walls.

Poulenc's opera ends with powerful music, as one-by-one the nuns are led to the guillotine for refusing to renounce their vows, which ensures their martyrdom. The composer David Lang wrote music, sung by Caroline Shaw and produced by Jody Elff, to accompany Bocanegra's altered midcentury nuns, who chose to sacrifice the trappings of secular life to join a celibate community of prayer and service.

Dialogue of the Carmelites, 2018. Collage, shelf, lights, looped soundtrack, and speakers. Dimensions variable. In collaboration with The Fabric Workshop and Museum, Philadelphia

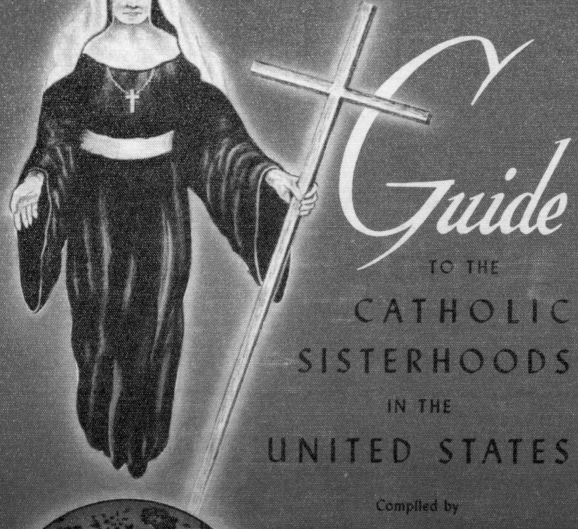

Guide

TO THE
CATHOLIC
SISTERHOODS
IN THE
UNITED STATES

Compiled by

THOMAS P. McCARTHY, C. S. V.

With foreword by

THE MOST REVEREND
AMLETO GIOVANNI CICOGNANI
Apostolic Delegate to the United States

DAUGHTERS OF MARY,
HEALTH OF THE SICK
Vista Maria, Cragsmoor, N. Y.

HISTORY: The Daughters of Mary, Health of the Sick were established in 1939 by Rev. Edward P. Gasersbe, S. J., with the authority of His Eminence, Patrick Cardinal Hayes. At the same time the Cardinal appointed Mother Mary Angela as Superior of the Community. Early in 1956 property was purchased for a motherhouse and novitiate at Vista Maria, Cragsmoor, N. Y. The Daughters of Mary, Health of the Sick are foreign Missionary Sisters, dedicated to the special vocation of imitation of our Blessed Mother under her beautiful and ancient title, "Health of the Sick." As Our Lady is the Health of the Sick both in soul and of body, so the sister's apostolate imitates her compassion through religious instruction to bring renewed physical help. A third phase of the work is the training of native women as catechists to be lay apostles among their own people. The sisters have fulfilled the request of the Holy See expressed in the Instruction of Feb. 11, 1956, for the foundation of new communities to devote themselves to help both mothers and babies in the missions. The wide scope of work offers an outlet for a variety of talents and training. After profession the sisters are trained for the work to which they will be designed. In addition to work in the U. S., a flourishing mission center has been established in Okinawa, Ryukyu Islands, and as time goes on the sisters will go into all foreign mission fields. The constitutions are based on the rule of St. Ignatius. There are no lay sisters in this community.

PURPOSE: Promoting the holiness and perfection of its members as they labor for the sanctified souls is the primary endeavor of this Institute. It is also dedicated to religious instruction, social service work, and the nursing of the sick in mission areas.

QUALIFICATIONS:
(Age: 15-19
• Applicants should be in peaceable and physically and have a vocation desire to serve God by sanctifying others in a missionary vocation.
• A high school diploma is desirable, but is not essential.

For further information please write to:
Mother Superior, D. M. H. S., Vista Maria, Cragsmoor, N. Y.

DAUGHTERS OF MARY OF THE
IMMACULATE CONCEPTION
New Britain, Connecticut

HISTORY: The Congregation of Daughters of Mary of the Immaculate Conception was founded in New Britain, Connecticut, in 1904, by the Reverend Lucian Bojnowski. Urged by the desire to honor the Blessed Mother in a special way, on the occasion of the golden jubilee of the proclamation of the dogma of the Immaculate Conception, and wishing to ameliorate the sad plight of orphaned children, Father Bojnowski, a zealous and pious priest, brought together a group of devout Sodalists from his parish and, with ecclesiastical approbation, formed the nucleus of the present Community.

PURPOSE: In accordance with Canon Law, the primary aim of the Institute is the personal sanctification of its members by the observance of the evangelical counsels, and secondly, to further the apostolate through the exercise of corporal and spiritual works of mercy. The Sisters are engaged in teaching on both the elementary and secondary levels, nursing, caring for the aged and infirm, giving catechetical instruction, conducting orphanages and residences for women.

QUALIFICATIONS: Applicants must:
• be between 15 and 30
• have a good moral character, average intellectual ability and good health.
• A high school diploma is desirable but not essential.

HABIT: The Sisters wear a simple royal blue habit, a black veil, a white coif, and a black rosary. A large miraculous medal, suspended on a blue ribbon, completes the garb of the Community.

For further information please write to:
Very Reverend Mother General, Immaculate Conception Motherhouse, Concord Heights, New Britain, Connecticut.

THE DAUGHTERS OF MARY AND JOSEPH

HISTORY: The Daughters of Mary and Joseph are one of four Congregations founded in 1817/18 by that remarkable Belgian churchman, Canon Van Crombrugghe. A born educator, an enlightened counsellor of state and church leaders, he is best known as the source of that freedom of religion and education, which Belgians still enjoy today. During that tragic period of religious subjugation under the Napoleonic and Dutch regimes, he was the greatest force of the spiritual regeneration of his country. Shortly after his ordination, while still principal of a Belgian college for boys, he founded Communities of men and women, who would foster the fire of faith in the hearts of children through the strenuous schools he himself established. Though the Daughters of Mary and Joseph (also called Ladies of Mary) soon had many foundations in Belgium, England and Africa, it was not until 1926 that, at the invitation of the Most Reverend Archbishop John J. Cantwell, they came to California.

PURPOSE: Its the novitiate, located in beautiful Riverhead outside Los Angeles, the future Daughter of Mary and Joseph learns the threefold aim of her order, namely: "the glory of God, the sanctification of the members through the simple vows of poverty, Obedience, Chastity, and the education of youth". Distinguishing qualities developed in the young candidate are: "an abiding love of Our Lady and St. Joseph, zeal for souls, and an abundance of cheerfulness in sacrifice".

QUALIFICATIONS: The Constitutions of the Daughters of Mary and Joseph were approved by the Holy See in 1851. Those who wish to follow them and to participate in the noble work of the nunnery should possess:

* a self-balanced mind
* sound judgement, good health, excellent character
* at least a high school diploma, and a desire to work.

HABIT: The Sisters wear a black robe and veil, headdress and wimple of white linen, a scapular and belt of Our Lady's blue. On the veil and on the front of the scapular are reproduced the emblem of their heavenly patroness. (see blank cover)

For further information please write to:

The Novitiate of the Daughters of Mary and Joseph, 7790 Ave Merced Crombrugghe, Los Angeles 45, California.

DAUGHTERS OF OUR LADY OF MERCY
Newfield, New Jersey

HISTORY: One evening as Bishop De Mari of Savona, Italy, walked through the streets of his See City, he encountered a group of young boys and girls whose behaviour was uncontrolled and vulgar. He addressed a few words of paternal advice to them and received, in reply, a shrug of the shoulders. Saddened at the prevalent attitude of his flock, he continued as he entered the Episcopal Palace, "Oh if I had some generous souls who would dedicate themselves to the education of these young souls". These words reached the ears of Benedetta Rossello who hastened to offer her services to the Bishop. Thus was founded on August 10, 1837 the Congregation of the Daughters of Our Lady of Mercy, whose Foundress, Benedetta Rossello, became Sister Mary Joseph. And on June 12, 1949, when Pope Pius XII raised her to the highest honors of the Church, Saint Mary Joseph Rossello.

PURPOSE: The specific purpose of the Institute is the Christian instruction and education of the children and youth of any condition, especially the poor and abandoned, and the assistance of the sick in hospitals. Therefore, the Sisters have in the United States teach in elementary and high schools, do mission work in parishes, and conduct a convalescent hospital and a nursery.

QUALIFICATIONS: Candidates who are accepted into this Institute must:

* be between the ages of 15 and 30
* have good health and present certificate of good conduct, Baptism, and Confirmation
* have a desire to glorify God, sanctify themselves, and work for the salvation of souls.

HABIT: The Sisters wear a neat, tailored habit of black serge. A coif of white, about the neck from which hangs the Franciscan Rosary. The head-piece consists of a black veil, and a long circular white guimpe worn around the neck.

For further information please write to:

Rev. Mother, Novitiate, Villa Rossello, Newfield, New Jersey.

DAUGHTERS OF

...about...

QUALI...

* ...
* ...
* ...

HAB... black... of se...

For...

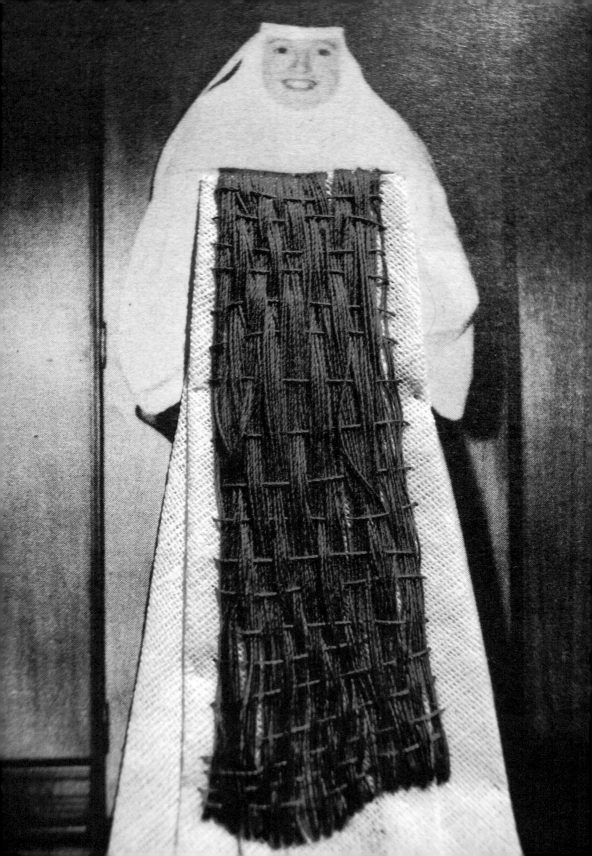

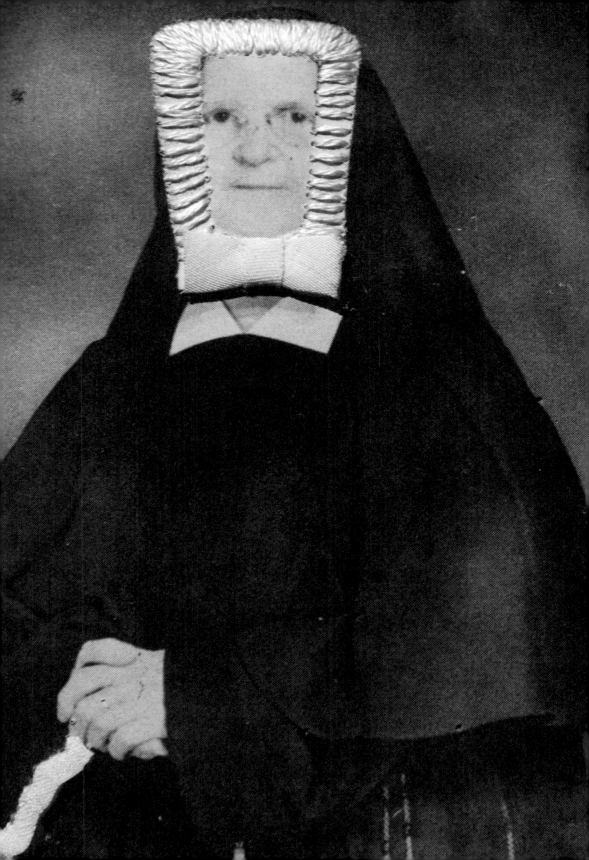

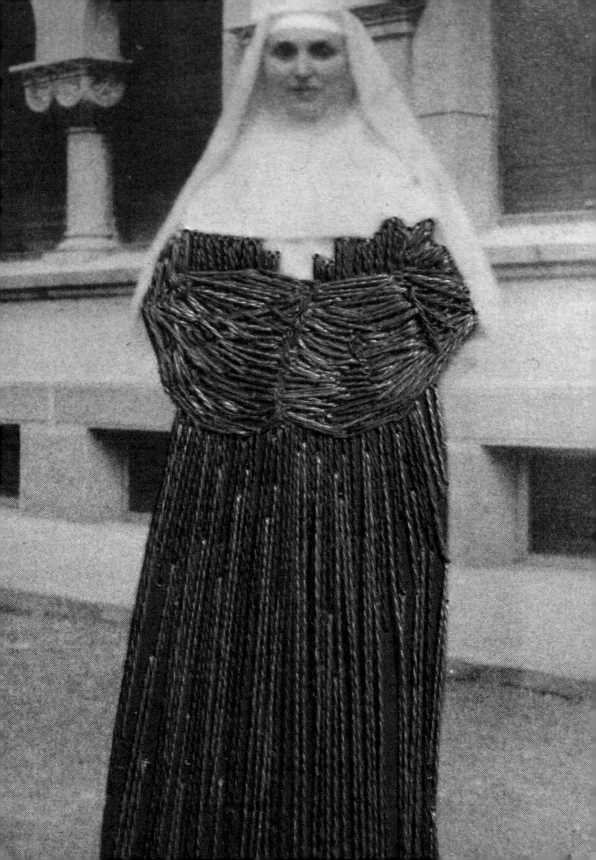

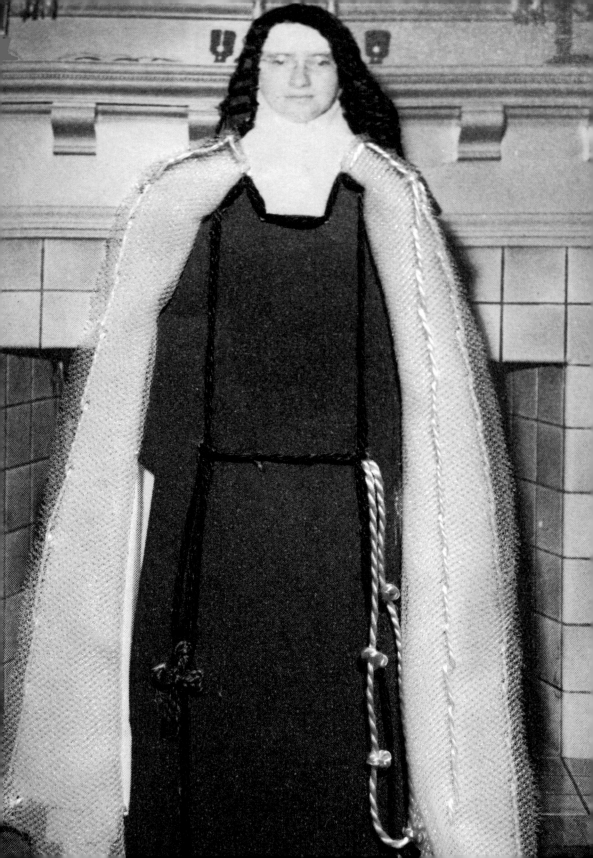

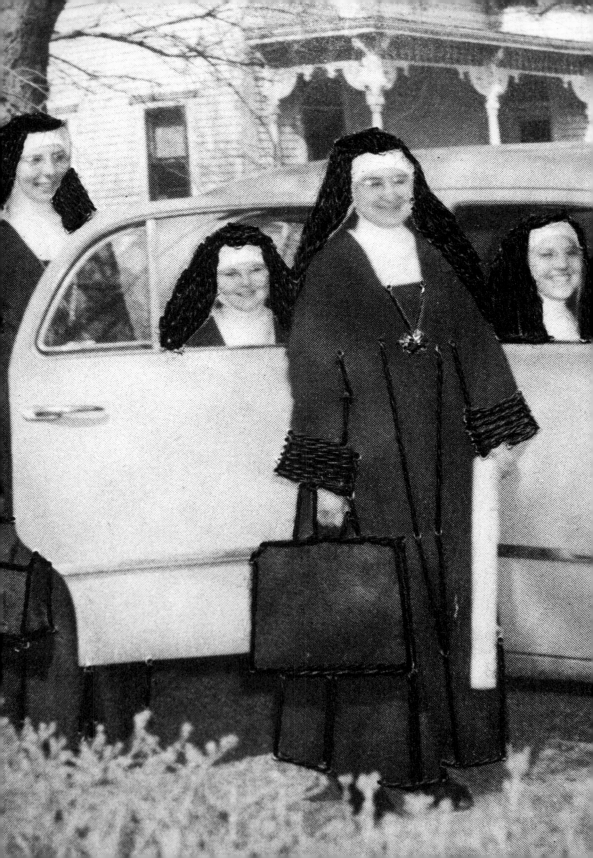

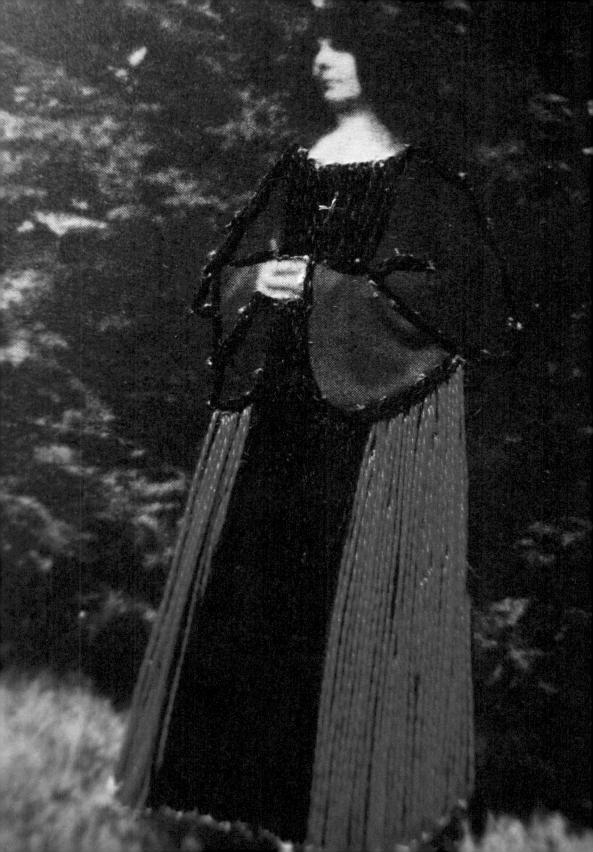

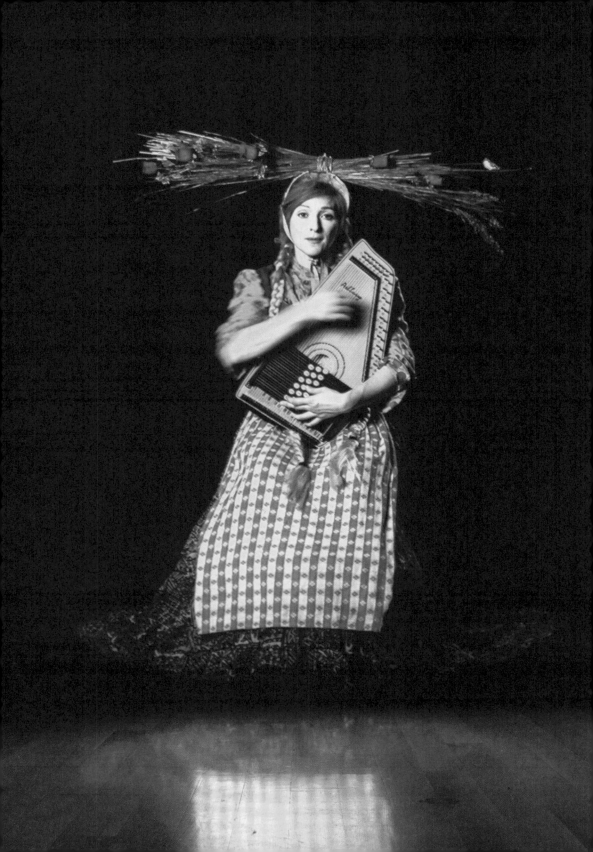

Lemonade, Roses, Satchel

Suzanne Bocanegra grew up in Texas, where her grandparents made their living on a small farm. She remembers it as a pastoral idyll, although her mother, who grew up on the farm, recalls a difficult and hardscrabble life.

For most of Bocanegra's life, her grandmother suffered from dementia. She asked the same questions and made the same simple declarations over and over again:

> *Would you like some lemonade?*
> *My roses are so beautiful.*
> *Why won't he* [Grandpa] *give me money for my satchel?*

In 2017, Bocanegra asked Shara Nova, My Brightest Diamond, to use her grandmother's words as the lyrics for a song. Bocanegra staged and costumed Nova invoking an exaggerated notion of the bucolic ideal.

Lemonade, Roses, Satchel, 2017. One-channel HD video (color, sound). 3:28 minutes

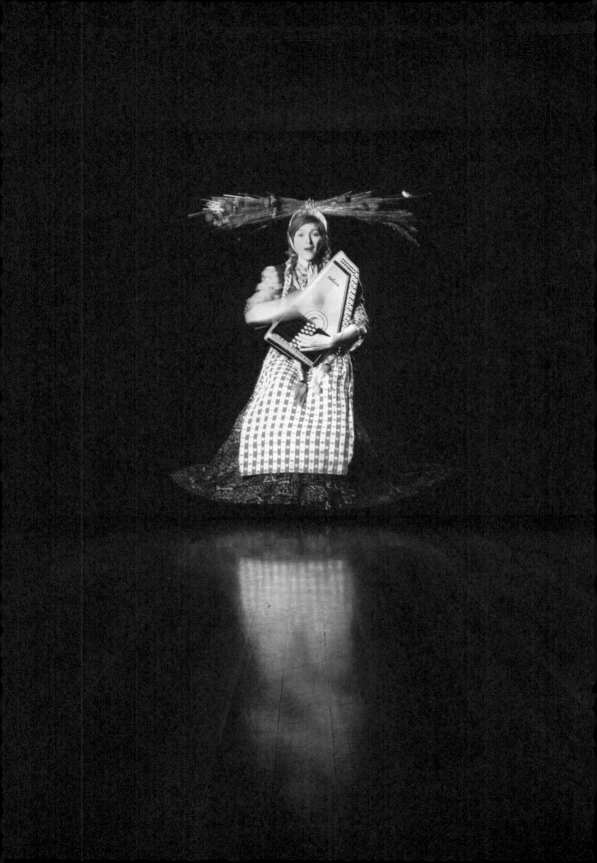

About the Artist

Suzanne Bocanegra, born in 1957 in Houston, Texas, lives and works in New York City. A recipient of the Rome Prize, she has received grants from the Pollock-Krasner Foundation, the Louis Comfort Tiffany Foundation, the Joan Mitchell Foundation, the National Endowment for the Arts, and the New York Foundation for the Arts, and research fellowships from the Smithsonian Institution and the Danish Arts Council. Her recent work involves large-scale performance and installation, frequently translating information, images, and ideas from the past into three-dimensions through staging, movement, and music.

Bocanegra's work has been presented in the United States in solo shows at the Frances Young Tang Teaching Museum and Art Gallery in Saratoga Springs, NY, and at SITE Santa Fe; and in group shows at venues including the Hammer Museum in Los Angeles, the Serpentine Gallery and the Victoria & Albert Museum in London.

Her theatrical, video, and film work has been presented at the Museum of Modern Art in New York; the Carnegie Museum of Art in Pittsburgh; The Kitchen in New York; Mass MoCA in North Adams, MA; the Henry Art Gallery in Seattle; the Wexner Center at Ohio State University in Columbus; the Walker Art Center in Minneapolis; the Pulitzer Arts Foundation in Saint Louis; the Center for the Art of Performance at the University of California at Los Angeles; EMPAC in Troy, NY; the Ace Theater in Los Angeles; Marfa Live Arts in Marfa, TX; the Next Wave Festival at the Brooklyn Academy of Music; the Fisher Center for the Performing Arts at Bard College in Annandale-on-Hudson, NY; the Fusebox Festival in Austin, TX; CounterCurrent Festival in Houston; and Abrons Art Center Playhouse, Danspace Project, and the Chocolate Factory Theater, all in New York, among others. In the theater world she is a frequent collaborator with Big Dance Theater, 7 Daughters of Eve Theater & Performance Co., and Pam Tanowitz Dance.

Suzanne Bocanegra was recommended as an Artist-in-Residence by The Fabric Workshop and Museum's Artist Advisory Committee (AAC)—a distinguished group of artists, curators, and scholars—and selected by Executive Director Susan Lubowsky Talbott and AAC Chair John Ravenal. Bocanegra's residency allowed her to experiment on a grand scale, while also presenting her work to a new audience at a pivotal point in her career.

Acknowledgments

For *Valley*

Principal Cast
Anne Carson, Deborah Hay, Joan Jonas, Alicia Hall Moran, Tanya Selvaratnam, Kate Valk, Carrie Mae Weems, Wendy Whelan

Background Cast
Suzanne Bocanegra, Paige Fetchen,* Theodora Lang, Nami Yamamoto*

Director of Photography
Meg Kettell, Full Aperture Films, Inc.

Line Producer
Taylor Shung

Movement Coach
Elizabeth Dement

First Assistant Camera
Rachel Fedorkova, Will Castellucci

Gaffer
Isabel Bethencourt

Sound Mixer
YongSoo Lee

Editor
Carly Tarricone

Video Installation
Josh Higgason

Costume Construction
Katherine Abercrombie,* Paige Fetchen,* Avery Lawrence,* Joy Ude,* Allen West,* Nami Yamamoto*

Hair and Makeup
Tarence Anderson, Carmilla Cunny, and Kinshasa Hunter of Cunny Studio's, Ltd.

Color Grading
Matthew Greenberg

Production Assistants
Frank S. Cooper III, Michael Tousana

Location
Elwood's Studio LLC, Brooklyn, NY

For *Dialogue of the Carmelites*

Composer
David Lang

Vocalist
Caroline Shaw

Producer
Jody Elff

Lighting Designer
Christopher Ash

Embroidery
Isabella Amstrup, Barbara Botting, Paige Fetchen,* Abby Lutz,* Allen West*

For *Lemonade, Roses, Satchel*

Composer and Performer
Shara Nova

Director of Photography
Meg Kettell, Full Aperture Films, Inc.

Producer
Drew Houpt

Line Producer
Sandra Garner, Lingua Franca Arts

Recording Engineer
Collin Dupuis

Gaffer
Lyon Taylor

Hair and Makeup
Marco Campos

Production Assistants
Hannah Ammon, Babbette Johnson

Location
The Performing Garage, New York, NY

Curator
Susan Lubowsky Talbott

Educational Programming
Performance
Lili Taylor

Program Development
Shelby Donnelly,* Katie Parry,* Christina Roberts*

Partners
Interfaith Philadelphia, Lightbox Film Center, Pennsylvania Academy of Fine Arts

Project Interns
Matt Balik, Jason Barr, Amaya Bullock, Emily Dombrovskaya, Angela Mele, Maya Williams

Exhibition Management & Coordination
Justin Hall,* Alec Unkovic*

Publicity
Andy Cushman, John Melick, Adam Mrlik, and David Simantov of Blue Medium

Catalogue
Interview
Hal Foster

Coordination
Stephanie Greene,* Karen Patterson*

Design and Editing
Takaaki Matsumoto, Amy Wilkins of Matsumoto Incorporated

*denotes FWM staff member

About The Fabric Workshop and Museum

The Fabric Workshop and Museum was founded in 1977 with a visionary purpose: to stimulate experimentation among contemporary artists and to share the process of creating works of art with the public. Providing studio facilities, equipment, and expert technicians, FWM originally invited artists to experiment with fabric and later with a wide range of innovative materials and media. From the outset, FWM has also served as an education center for Philadelphia's youth who, as printing apprentices, learn technical and vocational skills along with approaches to creative expression.

Today, FWM is an internationally acclaimed contemporary art museum; the only institution in the United States devoted to creating work with textiles and new media in collaboration with artists from such diverse backgrounds as sculpture, installation, video, painting, ceramics, and architecture. Research, construction, and fabrication occur on-site in studios that are open to the public, providing visitors an opportunity to see art being made from conception to completion. Ambitious exhibitions, publications, and wide-ranging educational programming enhance FWM's commitment to telling a story of contemporary art that highlights process along with product. FWM's collection includes not only complete works of art but also material research, samples, and prototypes, as well as photography and video of artists making and speaking about their work. FWM brings artistic investigation and discovery to the public, area schoolchildren in particular, to ensure and broaden their exposure to art and to advance the role of art as a catalyst for innovation and social connection. FWM offers an unparalleled experience to the most significant artists of our time, to students, and to the general public.

Marion Boulton Stroud (1939–2015), *Founder and Artistic Director (1977–2015)*

Susan Lubowsky Talbott, *Executive Director*

Board of Directors

Officers
Maja Paumgarten Parker, *President*
Jill Bonovitz, *Vice President*
Eugene Mopsik, *Treasurer*
Lynn Hitschler, *Secretary*

Board Members
Jason Briggs
Sarah Jackson
Timothy Kearney
Emanuel Kelly
Ann T. Loftus, Esq.
Mary MacGregor Mather
Laurie McGahey
Margaret "Maggie" A. McGreal
John Ravenal
Joseph J. Rishel
Georgina Sanger
Katherine Sokolnikoff
David F. Stephens
Cynthia Stroud

Theodore R. Aronson, *Emeritus*

Richard P. Jaffe, Esq., *Emeritus*

Anne F. Wetzel, *Emeritus*

Samuel H. Young, *Emeritus*

Artist Advisory Committee
John Ravenal, *Chair*
Ian Berry
Francesco Bonami
Dan Byers
Valerie Cassel Oliver
Mel Chin
Paolo Colombo
Kathie DeShaw
Matthew Drutt
Russell Ferguson
Jennifer Gross
Paul Ha
Ann Hamilton
David Allen Hanks
Jun Kaneko
Tina Kukielski
Rick Lowe
Lisa Phillips
Mark Rosenthal
Paul Schimmel
Bennett Simpson
Patterson Sims
Robert Storr
Olga Viso
Yoshiko Wada
Kara Walker

as of July 25, 2019

This book was published on the occasion of the exhibition
Suzanne Bocanegra: Poorly Watched Girls at The Fabric Workshop
and Museum (October 5, 2018–February 17, 2019) curated by
Susan Lubowsky Talbott, Executive Director.

Published in 2019 by The Fabric Workshop and Museum in
association with MW Editions

Support for *Suzanne Bocanegra: Poorly Watched Girls* is provided
by the Coby Foundation, Ltd.; The Andy Warhol Foundation for
the Visual Arts; the Joy of Giving Something, Inc.; the National
Endowment for the Arts; Maja Paumgarten and John Parker; Katie
Adams Schaeffer and Tony Schaeffer; and Henry S. McNeil.

The Andy Warhol Foundation for the Visual Arts

Major support of FWM is provided by the Marion Boulton
"Kippy" Stroud Foundation. FWM receives state art funding
support through a grant from the Pennsylvania Council on the Arts,
a state agency funded by the Commonwealth of Pennsylvania and
the National Endowment for the Arts, a federal agency. Additional
support is provided by The Philadelphia Cultural Fund, Agnes
Gund, and the Board of Directors and Members of The Fabric
Workshop and Museum.

 pennsylvania
COUNCIL ON THE ARTS

 The Philadelphia
Cultural Fund

The Fabric Workshop and Museum
1214 Arch Street, Philadelphia, PA 19107
www.fabricworkshopandmuseum.org
info@fabricworkshopandmuseum.org

MW Editions
127 W 26th Street, Room 900
New York, NY, 10001
www.mweditions.com
info@mweditions.com

Copyright © 2019 The Fabric Workshop and Museum
Texts © 2019 the authors
Artworks © Suzanne Bocanegra
All rights reserved. No part of this book may be reproduced or
transmitted in any form or by any means, electronic or mechanical,
including photocopy, recording, or any other information storage
and retrieval system, or otherwise without written permission from
the publisher.

Art Direction and Design: Takaaki Matsumoto, Matsumoto
Incorporated, New York
Managing Editor: Amy Wilkins, Matsumoto Incorporated, New York
Design Assistant: Robin Brunelle, Matsumoto Incorporated, New York
Editor: Amy Wilkins, Matsumoto Incorporated, New York
Project Coordination: Stephanie Alison Greene and Karen Patterson,
The Fabric Workshop and Museum, Philadelphia

Printed and bound at Industria Grafica SIZ, Verona, Italy

Library of Congress Control Number: 2019948534
ISBN: 978-0-9987-018-5-1

Distributed by D.A.P./Distributed Art Publishers, Inc.
75 Broad Street, Suite 630
New York, NY 10004
www.artbook.com
enadel@dapinc.com

Works created through the Artist-in-Residence program were made in
collaboration with The Fabric Workshop and Museum, Philadelphia

Front cover: Suzanne Bocanegra, *Lemonade, Roses Satchel,* (detail), 2017.
One-channel HD video (color, sound). 3:28 minutes
Front end papers, page 4, back end papers: Suzanne Bocanegra, *Dialogue
of the Carmelites* (detail), 2018. Collage, shelf lights, looped soundtrack,
and speakers. Dimensions variable. In collaboration with The Fabric
Workshop and Museum, Philadelphia
Page 7: Suzanne Bocanegra, *Valley* (detail), 2018. Eight-channel HD
video (color, sound). 4:44 minutes. In collaboration with The Fabric
Workshop and Museum, Philadelphia
Page 8: Suzanne Bocanegra works in progress at The Fabric Workshop
and Museum, Philadelphia
Pages 13–14, 19, back cover: Suzanne Bocanegra, *La Fille* (detail), 2018.
Mixed media. Dimensions variable. In collaboration with The Fabric
Workshop and Museum, Philadelphia
Pages 46, 48–51: Bust on pedestal by Luigi Pampaloni, *Girl of the
Turtledoves (Innocence)*, 1831. Plaster reproduction of marble original.
13 x 11 x 7 inches. Courtesy of Pennsylvania Academy of the Fine Arts
Historic Cast Collection

The quotation on page 47 from "The Diseases of Costume" is taken from
Roland Barthes, *Critical Essays*, trans. Richard Howard (Evanston, IL:
Northwestern University Press, 1972), 49.

Photograph Credits:
All photographs by Thibault Jeanson except on pages 44–45,
photographs by Carlos Avendaño

EDICTINE SISTERS OF PONTIFICAL JU[

GREGATION OF ST. SCHOLASTICA

ted in 1922 (12 Motherhouses)

bama—Sacred Heart Convent, Cullman, [nois—St. Scholastica Convent, 7416-7430 Ri nois; Benedictine Convent of the Sacred [ois; Kansas—Mt. St. Scholastica, Atchison t. Walburg Convent, Villa Madonna, (ington, Kentucky; Louisiana—St. Schola St., Covington, Louisiana; Maryland—S , Ridgely P.O., Wilmington, Maryland; Nev a Convent, 851 N. Broad St., Elizabeth, a—Benedictine Heights College, Guthrie ania—St. Benedict's Convent, 327-345 E. ania; Mt. St. Mary's Convent, 4530 Perry h 29, Pennsylvania; St. Joseph's Conve Mary's, Pennsylvania;

REGATION OF ST. GERTRUDE THE G

ed 1937 (7 Motherhouses)

—St. Gertrude's Convent, Cottonwood ent of the Immaculate Conception, Ferdin enedict's Convent, 3315 Lowell St., Sioux —Mt. St. Benedict Convent, Crookston ta—Sacred Heart Convent, 225 14th Ave ta; South Dakota—St. Martin's Convent, St d Heart Convent, Yankton, South Dako

REGATION OF ST. BENEDICT

d 1947 (3 Motherhouses)

esota—Convent of St. Benedict, St. Jos

devotio

Young

all Canon

by a right

of this pa

present cer

marriage, as

school

their